SEPTEMBER

A History Painting by Gerhard Richter

Robert Storr

Tate Publishing

Contents

Foreword

The destruction of the Twin Towers of the World Trade Center in New York on September 11, 2001 was an outrage of shattering audacity, scale, and originality. Its monstrosity still echoes, still defies the imagination, and still stirs a stormcloud of mixed emotions. If, as Robert Storr writes, the finest contemporary art is a means for contemplating the unanswered and sometimes unanswerable paradoxes of modern life, then 9/11 is its most demanding possible challenge.

9/11 was not simply a uniquely shocking act of destructive violence. Unlike most violent events it was designed to be witnessed, directly or indirectly, by the maximum possible number of people all over the world. It was meant to be photographed, televised, and disseminated by the world's media, and it was. Combined with the simultaneous attack on the Pentagon, it was intended to symbolize the most radical possible upending of the existing order, the triumph, as Storr puts it, of relative weakness against disproportionate strength. Storr analyzes the very different ways in which this symbolism was interpreted by different groups. Particularly in the United States, 9/11 has dominated, and sometimes distorted, discussions of both national security and foreign policy and it still remains an open wound, a source of rage, pain, alienation and extreme anxiety.

In his remarkable treatise which opened the catalogue for the great 2002 MoMA exhibition, *Gerhard Richter: Forty Years of Painting*, Robert Storr described Richter in these words. "A broadly philosophical painter, more than a strictly conceptual one, a radical thinker and often traditional maker, among the great artists of the second half of the twentieth century, and a front-line explorer of the twenty-first, Richter is an image-struck poet of alertness and restraint, of doubt and daring."

Richter is not new to terror-related subjects; his series on the Baader-Meinhof group that terrorized Germany in the 1970s now hangs at MoMA in New York, and at first caused much controversy. 9/11 is in almost every way a far larger and more complex subject. Storr has called on his unmatched knowledge of Richter's work as well as his personal acquaintance with the artist, to analyze both the painting of, and the philosophy behind his small but powerful painting, *September*.

Storr suggests why this ostensibly modest work has such subtle and incremental emotional impact. He also meditates on how the process of producing it, literally by scraping away much of the original painting and by muffling the earlier depiction of the fireball caused by collision of plane and tower, has deepened the meaning and impact of the work. The result, Robert Storr writes, has been "to render the simple, absolute, but always elusive reality of human suffering."

Sir Brian Urquhart

One Fine Morning
Chapter 1

The subject of this essay is a single painting by Gerhard Richter: *September*. It was painted in 2005, four years after "the decisive moment" of September 11, 2001 that it arrests, holds in perpetual suspension but refuses to embody. In the service of critical disinterestedness, many art historians and other types of professional art writers might take a step back before discussing such a work and start by adopting a voice reflecting some measure of detachment from the matter at hand. In this case, that is impossible. Instead, I must begin by speaking in the first person. This is necessary because the work under scrutiny focuses on things I saw and heard, things that happened to me or happened to others before my own eyes or within earshot. Beyond that scope, it concerns things that happened to people I know who told me with little or no delay what they had seen and heard and said and thought and felt during the same day or in the days immediately after it, days that are fused in memory like clear glass bottles melted into one another by a searing heat that partially coated them with ash.

Although I believed at the time that what I had witnessed would be indelibly etched in my mind, since then I have been forced to contend with the ways those traces are now crowded by, and to a certain extent conflated with, the thousands of other images of the same situation seen from different angles through different lenses. Some of these second-hand images I have glimpsed in passing once or twice, some I have been confronted with dozens if not hundreds of times, and still others I have poured over for hours during the eight years since 9/11/01.[1] The paradox embodied in each of those pictures is exponentially amplified by their aggregate. Its essence emerges with the realization that the closer those pictures appear to bring me to aspects of what I directly saw, albeit from a considerable physical remove and from only a couple of vantage points, the farther away my experience of that day seems to

become, the more remote and—when such an image roughly approximates my own recollection—the less sharply defined even my most vivid recollections are. Of course, this is a paradox at the core of every representation, but it is starkest and most resonant for those who can compare a given depiction of a phenomenon to their memory of its unmediated perception.

If, in order to address Richter's painting, I am obliged to consider the public iconography of 9/11/01 and that iconography's larger context as the work's inseparable background, prior to fulfilling that obligation I am compelled to account for my own mental snapshots, those frozen glimpses of reality that are effectively the background to that background. Yet the particularities of such retinal imprints and their psychological and intellectual impact remain so fresh and so profound that they still refuse to fall into place behind the other two representational orders, even when the boundary between the first hand impression and those two orders begins to blur.

This residual, intransigent vividness triangulates the familiar binary tensions in Richter's art between the photograph and the painted picture. Moreover, it adds a third term generally not at issue in his other works. This is true because the scenes he has habitually chosen to recreate in the past derive for the most part from found sources—family pictures, newspaper items, landscapes, aerial cityscapes—that contain few if any people who were unlikely to have been seen by more than a handful of on-lookers when the image was captured. The exceptions are pictures of larger clusters, groups or crowds of people; but more often than not, the situation's center of attention is ambiguous, making each person's specific relation to that ill-defined center and to the other individuals inside or outside the frame almost impossible to discern and harder still to compare.

Not so with the destruction of the World Trade Center on 9/11/01. That morning, masses of people were suddenly caught up in a highly concentrated event in which everyone within visual range of its locus

was both a protagonist and a spectator. Many of those spectators had cameras or video equipment, with the result that eye-witnesses without any conventional reportorial role to play were nevertheless recording history and generating the secondary images that would at once complete and compete with what others who were also eye-witnesses were documenting at the same instant, along with the still greater number who watched but made no permanent record. Within this constellation of participant/observers could be found every imaginable type of New Yorker as well as a host of non-New Yorkers. It was a collective whose only common denominator was being there - then.

On the morning of 9/11/01 I found myself in an outer ring of the circles radiating around what was soon to be known as Ground Zero. While I could see nothing of what occurred at street level, I had an unimpeded view of the upper floors of the World Trade Center (WTC). My neighborhood was in Brooklyn, right across the East River from the Financial District of lower Manhattan. Some of my neighbors were en route to work or already at work in the vicinity of the WTC when disaster hit. As such, my family, our friends, and I were nodes in the tessellated pattern of watchers just described; and insofar as we were straight downwind from the noxious plume of smoke and debris that blew from the west when the towers burned and ultimately collapsed, we also had a bitter taste of the holocaust that transfixed us.

Taking into account the compound stimuli—the acrid odor of the smoldering ruins, the sirens, the unfolding vision and growing intuition of horror—coupled with an acute though imprecise awareness of my own potential vulnerability and that of others who shared the experience at different proximities to the greatest dangers, as well as a simultaneous awareness of the fundamental incommensurability of the degrees of jeopardy that separated those at the core of the event from all outside of that core, the conceptual distinction between objectivity and subjectivity, distance and lack of distance lose their precision. And, in the jarring unpredictability of circumstance, they also lose a good deal of their meaning. As much as anything, that loss of bearings, those imploding

distinctions are what most shocked my nervous system and permanently altered my consciousness. So, before trying to describe Richter's *September*, its genesis, its place within his oeuvre, its unique status among images of 9/11/01, and its significance to contemporary art, I will tell the reader what the sights and sounds of that day were when disaster struck.

NB.

An initial, privately published and subsequently abandoned edition of this book appeared in the Fall of 2009 to coincide with the first public unveiling of *September* in New York at the Museum of Modern Art to which the painting had been jointly given by the artist, Gerhard Richter, and his friend and patron Joe Hage. In the rush to meet that deadline some errors in the essay escaped notice. In this new, first edition of the book those mistakes have been corrected and some new material has been added.

1

Throughout this essay I have used the date 9/11/01 in lieu of the standard journalistic abbreviation, "9/11." The intent behind this is twofold. First, it renders the date of the attack on the World Trade Center in full for simple accuracy's sake. Second, it locates the event in history rather than isolating it in its own ambiguous yet "branded," moment. As time passes and the last two digits of the formula roll over into 9/11/10, 9/11/11 and up, readers who do not recall the day in question or the year may be grateful for complete information. More importantly, though, designating the day with just two numbers accords it a politically tinged uniqueness in the annals of modern violence that effectively sets it apart from other, more destructive events. President Franklin Delano Roosevelt declared the Japanese sneak attack on Pearl Harbor in 1941 "a day that shall live in infamy" but we do not speak of 12/7 and by this point generations of Americans born after World War II might well be in doubt as to whether it would in that case refer to 12/7/39, 12/7/40 or 12/7/41. Meanwhile, no one speaks of the American bombing of Hiroshima in 1945 as 8/6, though by ushering in the age of nuclear warfare that surprise attack on a largely civilian target was of inarguably greater importance historically than 9/11/01.

Moreover, there is another 9/11 in recent history that few North Americans look back on but many South Americans have reason to commemorate as a day of upheaval and loss: 9/11/73. On that day, with the covert backing of the United States, General Augusto Pinochet overthrew the legally elected Socialist President of Chile, Salvador Allende, ushering in a reign of terror that claimed the lives of thousands of citizens who were made to "disappear" by military and paramilitary death squads. In a multi-media installation, *Arrest*, especially created for a thematic exhibition called "The American Effect" that was mounted at the Whitney Museum of American Art in 2003 and to which non-Americans were invited to contribute works addressing some aspect of the United States's image abroad, the Chilean artist Cristóbal Lehyt juxtaposed videos of the observation platform at Ground Zero in downtown Manhattan and an unauthorized photo of the entrance to a military school in Santiago, explicitly making a connection between the two events while purposefully complicating the reductive notion of the War on Terror proclaimed after 9/11/01.

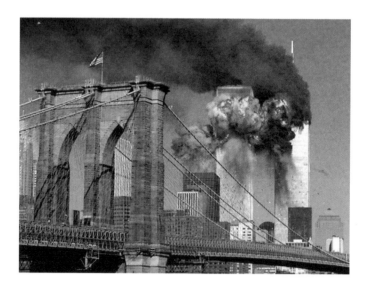

Chapter 2

This narrative portion will be fragmentary. Its contents are the mental snapshots of which I have just spoken, or in some cases mental videos and in others mentally recorded telephone conversations. All events and impressions are rendered as accurately as memory permits and with maximum concision. None are embellished by second thoughts or ex post facto insights, although a few factual details I learned later have been added. Any interpretive elaborations of my own experience that are germane to the larger points I wish to make in this essay will appear later on.

September 11, 2001 was the first day of fall classes for my two daughters. My wife walked them to school at seven forty-five. I remained at home. Twenty minutes after I finished *The New York Times* and sat down to write, the windows next to my desk shuddered, and I felt a distant concussion. That was unusual; but in our part of the city, near the Brooklyn-Queens Expressway, the Brooklyn-Battery Tunnel, and the docks, collisions and other loud noises are not entirely out of the ordinary. Just as my wife got home from dropping the girls off, the phone rang. When she answered, a friend living nearby exclaimed, "Oh my God, there's a fire at the World Trade Center! We can see it from here." (At 8:45, American Airlines Flight 11 from Boston ploughed deep into the North Tower and disintegrated.) In another room, my wife tuned the television to the local news, and shortly after that beckoned me to join her. The reception was bad, since we lacked cable; and so, because we were eager to know what was going on, we went down the block to join our friend in her brownstone. While we were walking the four blocks, a second plane hit the WTC. (It was United Airlines Flight 175, also from Boston, which crashed into the South Tower at 9:03 and exploded on impact.)

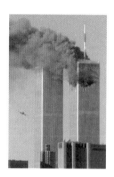 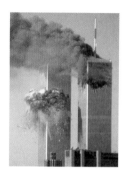 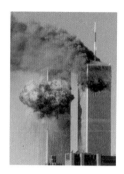

Upon arriving at our friend's house, which overlooked the East River, we went straight to the fourth floor and clambered out a window onto the steel grate of the fire escape. From there we had a direct view of the Twin Towers silhouetted against a clear sky. Both towers had scorched sides, and one had a gaping black cavity that was plainly visible to the naked eye. We weren't able to see—as those in Manhattan only a few city blocks away from the WTC readily could—the men and women who, gasping for air, stuck their heads and bodies out of the broken windows and vainly tried to escape the inferno within. Neither could we see those who jumped in desperation; nor could we hear the ghastly sound of bodies landing on the pavement as many in lower Manhattan did, including close friends who described the appalling sight to me.

From our observation post in Brooklyn, we could see smoke rising from the two towers as if from gigantic candles. What looked like white seagulls swirled around them, although, in fact, this was a cloud of paper wafting from the fractured façade of the buildings and carried aloft by a strong breeze. Except for the smoke and that scintillating cloud, the sky was a breathtakingly pure azure.

After watching the towers burn for a quarter of an hour or so, we went downstairs to see if we could learn from the television what was going on. The newscasters were unsure themselves; but after initial speculation that a private plane had strayed into the WTC, it became obvious that the double calamity was no accident. Two other planes south of New York that were, apparently, off course were being carefully tracked.

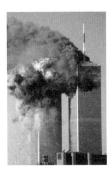 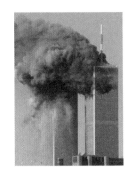 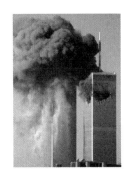

As soon as it was confirmed that some kind of attack was under way, we called our daughters' school and learned that the principal had gathered students into an assembly. Shortly after our call, we saw the South Tower implode on television, after much guesswork by newscasters about the WTC's structure and strength. (The towers were designed to withstand a direct hit by a fully fueled 707, but the planes that were used were larger and heavier than that.) The collapse came at 10:05, just over an hour after the first strike. Meanwhile, the assembly at our daughters' school was dismissed and classroom televisions were turned on, around which students and teachers crowded. The school was ten blocks from where my wife and I were and only a few short miles as the crow flies from the WTC, in and around which the parents of many other students worked.

After a second call the school agreed to release children to their families and promised to provide for those whose families could not come to pick them up. When we arrived, a number of students were running hysterically through the hallways. We found our daughters in the school's lobby. Our nine year-old was distraught because the mother of her best friend was a senior staffer of the New York and New Jersey Port Authority that had built, still operated, and had its main offices in the WTC. Both daughters had been watching the images on television. "All there was, was smoke," the youngest remembered. "People were taking pictures and they were just pictures of smoke."

By this time the air in our neighborhood was filled with ash, scraps of paper blowing in the wind, and the heavy pall of a chemical or electrical

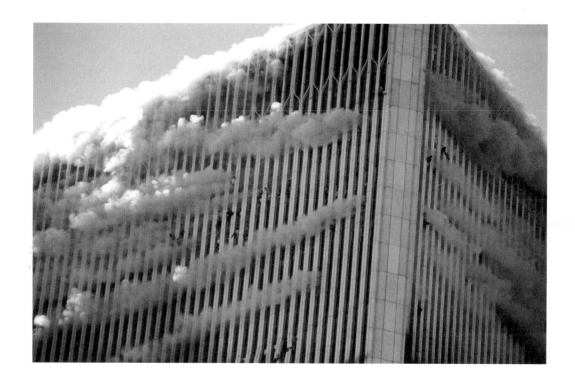

fire. To protect our daughters as best we could while walking away from the school, we asked them to cover their mouths with some hand-kerchiefs I pulled from my pocket. My wife and I did the same, using only our hands. Even across the river from the WTC the atmosphere was almost suffocating. Yet only that stench and knowledge of its source prevented me from wondering at the beauty of the flurry of gray and white particles and kiting tatters.

We returned to the house of our friends with the fire-escape view and discovered that members of several other families had joined them. Together we watched the North Tower fall. (It happened at 10:28.) I did not know then that Michael Richards, a young artist I had met while installing exhibitions at the Museum of Modern Art, had spent the night in a studio atop the WTC made available to him by the

Lower Manhattan Cultural Council. One of his sculptures was a cast of his own body covered by toy airplanes.[1] He vanished when the North Tower buckled and sank into its foundations.

Interspersed with on-site television coverage of events in New York were reports of the two other hijackings. The first, we learned, involved American Airlines Flight 77 from New York, which had slammed into the Pentagon in Washington D.C. at 9:43. The second involved United Airlines Flight 93 out of Newark, which crashed mysteriously at 11:26 in a rural area south of Pittsburgh.

One of the friends watching the news with us was a nurse at St. Vincent's Hospital on 12th Street and Seventh Avenue in Manhattan, just north of the WTC. Although it was her day off and travel to Manhattan was extremely difficult, not to mention perilous, she decided to go into work in anticipation of casualties arriving at the Emergency Room she supervised. Later in the day, she called to say that none had arrived, indicating the enormity and completeness of the losses.

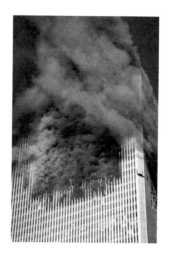

Toward the end of the morning, I headed home on foot to close the windows. (For the next six months doors stayed shut and windows were firmly sealed at our house despite intermittently warm and pleasant weather and government assurances that the fumes from continual fires in the WTC ruins posed no health hazards.) Before locking the backdoor of our brownstone, I walked around the garden behind it. The ground was covered with airborne litter. Most of the bits and pieces of paper were from business manuals and spreadsheets. One that I picked up was a page from a history of the Civil War dealing with the Battle of Antietam.

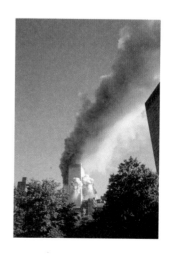

From a chance meeting on the street with the father and sister of our youngest daughter's best friend, I learned that her mother had gone to the polls to vote in a primary election prior to heading into Manhattan and so had not been at the WTC at the usual hour. Invited by them to their house, I found the mother on the telephone trying to determine

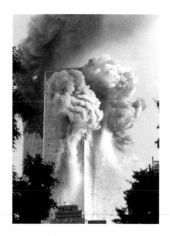

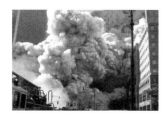

who among her co-workers had been at the office when the attack began and how many had managed to escape. One of her colleagues who was wheelchair bound had been carried to safety just prior to the North Tower's collapse. The mother devoted most of the rest of the day to locating the remainder of her co-workers and making a list of those unaccounted for. During the course of the afternoon, she went out to the stoop in front of her house and recognized papers from her office that had blown over the river and landed there.

At the end of the afternoon my eldest daughter and a group of her friends walked back up to the promenade in Brooklyn Heights that overlooks the financial district of downtown Manhattan across the East River. Several nights later it would be the site of a candle light vigil the entire family attended. In the fading hours of 9/11/01 she watched the smoke rising from and hanging over the ruins of the Twin Towers and the glow of search lamps trained on them. Thinking back on it years later she recalled with visible uneasiness that she was excited by the vista. For the first time in her life she was present as a part of history.[2]

The specifics and chronology of much of the rest of what happened on 9/11/01 remain elusive, but a few more details from it and the days following stand out.

Despite a recent influx of upper-middle-class people of various origins and professions that had gradually changed the character and complexion of the previously working class neighborhood where we live, our community was populated by several readily identifiable ethnic groups. The largest element was first-, second- or third-generation Italian-Americans with roots in Puglia and Sicily. After that came Hispanic-Americans from different countries as well as African-Americans, many of whom live in housing projects at the edge of the area. There is also a sizable Arab-American contingent. Most of the latter group consists of new arrivals from Yemen, Lebanon, Syria, and Palestine, but some who have come from these places settled in Brooklyn long ago.

A high percentage of the older Arab-American immigrants are Maronite Christians, but the majority of the more recent ones are Muslims. A considerable portion of the latter dress in traditional garb with the men wearing skullcaps and the women and girls wearing head scarves. Arabic is heard frequently on the street. Atlantic Avenue, a main thoroughfare that crosses the neighborhood west to east, boasts restaurants, coffee-houses, grocery stores, bakeries, clothing stores, and general emporia that sell everything from utensils and luggage to knick-knacks, hookahs, and rugs. There you can also find decorative carpets and objects featur-ing architectural monuments and famous mosques in the Middle East, secular music and films and recorded sermons and religious tracts, including those of Osama Bin Laden's spiritual and political mentor, Muhammad Qutb.

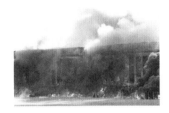

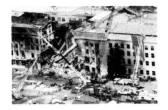

The cultural continuum spanning the Arab-American stretch of Atlantic Avenue is marked at one end by the well-established gourmet market Sahadis and at the other end by the Al Farooq Mosque, where the blind cleric Sheik Omar Abdel Rahman held forth before he was arrested and tried for complicity in the 1993 bombing of the World Trade Center, an attack planned by Khalid Shaikh Mohammed, who also masterminded the second and successful attempt to bring down the WTC.

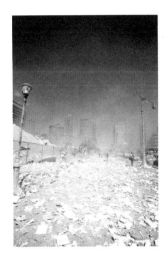

Sometime during the day or days immediately following the attack on the WTC, blue police barricades went up in front of businesses owned by Arab-Americans near the intersection of Atlantic Avenue and Court Street. I stumbled on them while running an errand. However, in spite of the shockwaves set in motion by the events of 9/11/01, the tensions created by the political rhetoric already beginning to influence public perception of the event, and the degree to which the calamity became an intimate matter in every corner of our neighborhood (local fire stations and police precincts that sent firemen and officers across the Brooklyn and Manhattan Bridges to the WTC had suffered heavy casualties), there were no reprisals against the local Arab community. Thus the police bar-riers were tangible evidence of something terrible that did *not* happen.

On September 17, 2001, President George Bush went on television to name Osama Bin Laden as the man behind the assault of the week before. "I want justice," Bush declared. By way of emphasis he added, "And there's an old poster out West, I recall, that says, 'Wanted: Dead or Alive.'"[3] With barely a second's pause, our youngest, still badly shaken but media-savvy daughter responded, "I bet he's been waiting his whole life to say that!"[4]

From that press conference onward there was also much talk on the part of the President and others in official capacities about the hijackers of 9/11/01 having been "cowards." In that context, I got a telephone call from my father, who has served in the United States Army Air Force during World War II and who had witnessed kamikaze pilots in action. He expressed deep distaste for such statements. As best I can recall, his words were, "We hated the kamikazes and we feared them, but we never thought they were cowards. Men who kill themselves trying to kill you are not cowards."[5]

Around the same time, I received a call from my aunt, who was born in Germany to a Jewish father and a Gentile mother. She had lived incognito in Berlin and Bavaria until the end of World War II and had experienced both the threat of being exterminated by the Nazis and the terror of saturation bombing by the Allies. Ever alert to the harsh lessons of that experience, she expressed deep concern for what had happened on 9/11/01 but noted that the actual toll of death and destruction was a fraction of what she had known in her youth. Furthermore, she pointed out that until this happened, few civilians in America had ever been targets of an implacable enemy, and none had had such an enemy come to their doorstep. As shocking as the attacks were, she warned, we must not lose our sense of proportion, lest exaggeration and overreaction further imperil, or even pervert, the America where she had sought and found safe haven.[6]

On September 13, 2001, Gerhard Richter was scheduled to appear at the opening of an exhibition of his new paintings at the Marian Goodman

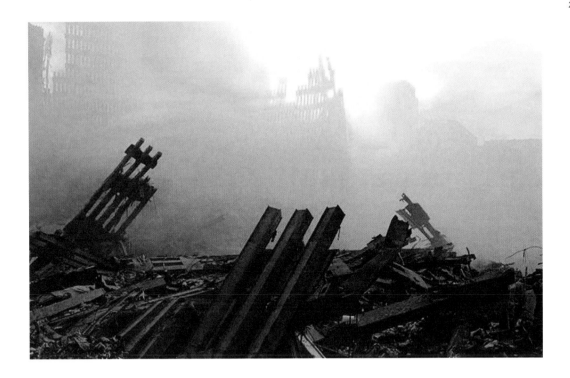

Gallery in Manhattan. At 8:45 AM on 9/11/01, when the first plane crashed into the World Trade Center, Richter and his wife Sabine were on Lufthansa flight 408 from Cologne, scheduled to land in Newark at 12:30 PM. At 10:24 the Federal Aviation Authority closed air space over the United States and diverted incoming transatlantic traffic to Canada. Richter's plane landed in Halifax, Nova Scotia, and he and his wife returned to Cologne on the 13th.[7]

1
Michael Richards is perhaps best known as an artist for his sculpture commemorating the World War II era airmen who came from the historically black Tuskegee Institute. Invoking the martyrdom of Saint Sebastian the monument consists of a life cast of Richards' own body covered with models of military planes.

2
Katharine Storr to the author, September 2009.

3
George Bush on CNN, September 17, 2001.

4
Susannah Storr to the author, September 17, 2001.

5
Richard J. Storr to the author, September 2001.

6
Gabriele Vawter to the author, September 2001.

7
Although it is not significant to the narrative, I was in touch with Richter once he and his wife arrived in Nova Scotia and I arranged for my brother and sister-in-law who live there to welcome them and look after their needs. It was Richter's first time in Halifax since 1978 when he was invited by Benjamin Buchloh to teach as a visiting artist at the Nova Scotia College of Art.

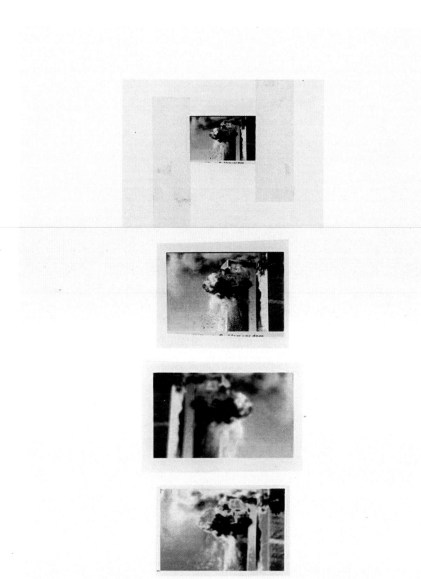

Detail of *Atlas* Sheet 744 2006

Chapter 3

On 9/11/01, tens of thousands—if not hundreds of thousands—saw, or at least caught a glimpse of, the catastrophe at the World Trade Center. They were on the street or in buildings nearby; they watched from office blocks and skyscrapers further uptown, or looked down the wide thoroughfares from Seventh Avenue to the West Side Highway; they stood at the water's edge, on promenades and docks, in parks, in warehouses, in apartments, and on roof tops; on the Hudson River and the East River or on Staten Island, Governors Island, and Ellis Island. Some were in boats in New York Harbor. Until air space over the city was shut off, some were in planes and helicopters. I have described where I was and what I observed and thought. All other eyewitnesses had their own vantage points and their own reactions.[1]

The differences among their experiences and narratives aren't like the self-interested retellings of an intimate confrontation explored by Akira Kurosawa in his many-sided film *Rashomon*. Yet divergences and distortions of varying kinds enter into the story of 9/11/01 because from beginning to end the event was exhaustively documented from multiple angles. At the outset these differences were relatively little influenced by overt political considerations. That came later, albeit not much later, given the accelerating rhythms of the daily news cycle in times of crisis and the speculations that substitute for facts as breaking stories are patched together by talking heads.

For the first hour and thirty-eight minutes of the crisis, most reports centered on sketchy information from people on the spot or near it as well as from agencies charged to respond to the emergency that had rushed representatives to the scene. As the nature of the emergency fully revealed itself and police, firemen and rescue workers attempting to get near the site crossed paths with victims or potential victims

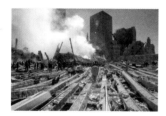

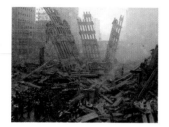

hastening to leave it, the number of people in a position to say "I saw it happen" swelled, only to be partially decimated when the denouement came and the fall of the two towers buried two thousand seven hundred and fifty-two people. One person close to the scene at the very end saw another man a little closer still who raised his arm and spasmodically shook his wrist at the billowing dust about to engulf him; the observer realized that the man was in a hysterical state and was desperately attempting to switch off reality with an imaginary remote control wand, and so, at the flick of his finger, trying *not* be there and *not* to see it happen.[2]

Among the most horrific and moving of testimony was that of office workers trapped on the upper floors of each tower who somehow managed to telephone family, friends, and others before their death. In most respects, the first public reports of the disaster were much like those of other crises in that the primary questions concerned what had caused it, how bad it was, or how bad it would get. Except for officials with privileged data about the buildings, the planes, the available resources, the pace of rescue operations and what was actually happening within the WTC—to the extent that anyone had comprehensive knowledge about that—all there was to go by was what the eye could see. One's perspective on the calamity was quite literally confined to optical phenomena.

Politics entered the equation once those scant facts about the perpetrators that were available, coupled with stock characterizations of them as categorically Other, made it open season for ethnic and ideological stereotypes; once the rhetoric of "the global war on terror" began to reduce the crucial distinctions between Sunni and Shia, Iraq and Iran, Osama Bin Laden and Saddam Hussein to a cratered Ground Zero of historical analysis and critical thinking; and once questions about who should have anticipated the attack or, in fact, did anticipate it but failed to act, were raised. The simultaneous and contradictory processes of investigation and mystification set in motion by such confusion are too vast to address in depth here. Inevitably, though, they contribute to the meaning of any image of the besieged Twin Towers to the extent that

ever since the attack the Pandora's box of political and cultural specters released by it have hovered in the air like the fluttering nimbus of paper that briefly arose over the actual site. Unlike that nimbus, these specters have yet to dissipate and so continue to obscure our view of the event and its meanings.

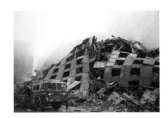

In the initial stages of the attack on through the complete demise of the WTC, the major basis of difference among those who saw it happen were physical degrees of separation, qualified by differences in their immediate stake in the outcome and fundamental differences in social identity and psychological resilience. Who actually died, who risked death, who endured the death of someone close to them, who feared for their own lives or that of someone else, and for how long during the day or the days following did that fear possess them? Who lost a job or an apartment or, in some subtler or more insidious manner, lost a defining illusion and so lost a way of life? In short, what kind of trauma was visited upon each and every person whose eyes were trained on the WTC or as much of it as they could make out depending on their vantage point?

Given those differences, to whom does the destruction of the WTC "belong" as an existential reality or as an image? The intensity of feeling surrounding that question can be measured in the aching voices of those who have read aloud the names of their dead on September 11th of every year since the attack, just as the variousness of those names and of the faces of those who recite them make plain that true "Americaness" is neither monochrome nor monocultural. Rather, as Walt Whitman so clearly saw it, America is a multitude of differences. That intensity is also manifest in the emotionally charged debate over what constitutes a fitting monument to the victims of the attack and the lack of agreement even among those who suffered most grievously and mourn most bitterly. On that score, one should be alert to the emergence of a psychological phenomenon largely new to Americans, but deeply ingrained in those who have had their reality blown apart or slowly obliterated: survivor guilt. Much of the passionate contention over the memorializing of

Next page: Richter's studio, Cologne

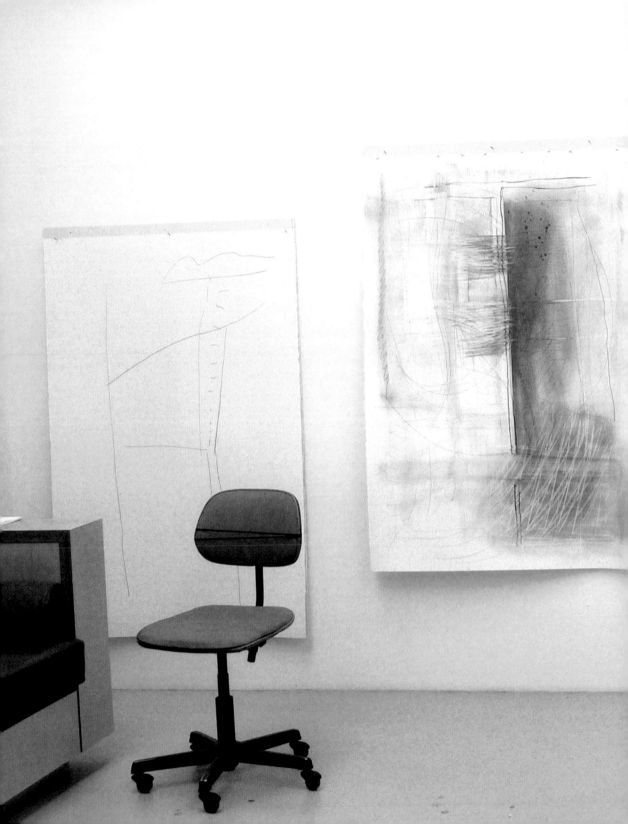

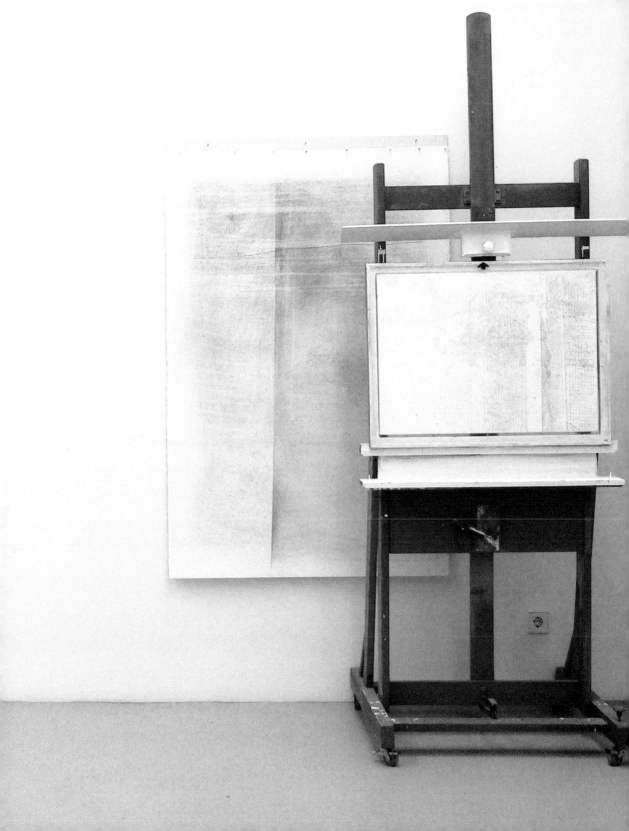

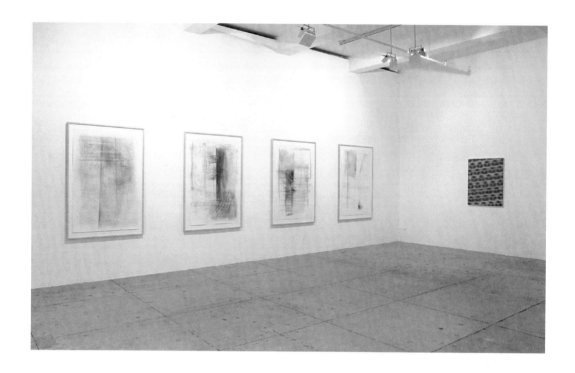

9/11/01 has come from people who escaped the fate that befell the person sitting or standing or running next to them, in the office or by the elevator or on the stairs, or out on the sidewalk in the shadow of the crumbling towers. This guilt extends to those who never came near the scene but cannot forget their intimacy with others who never left it. Even as they ask, "Why him? Why her?" in reference to a family member, friend, or co-worker who was lost, they are implicitly asking, "Why not me? What did I do to deserve life? How in the world could someone else have deserved death?" In survivor guilt, relief and regret become excruciatingly, inextricably knotted, and the simple fact of not having died when others did can become a lifetime curse.

At the heart of the debates over formal remembrance are three irreconcilable factors. First, there is an implicit, if not explicit, quantification of pain, the invidious comparison of degrees of anguish. Second, there is a

Installation view
Marian Goodman Gallery, New York 2005

desire to ennoble those who perished by raising a memorial that speaks to their "heroism," even though the majority of those who died did so without having chosen any aspect of their deaths as heroes traditionally do. Nevertheless, from the accounts we have, many people at the scene acted bravely and some with astonishing and truly selfless courage in the face of circumstances all but entirely beyond their control. Their actions, and their sacrifices do give heroic dimensions to the ordeal both individually and collectively.

The third factor is patriotism. In the search for meaning in death, love of country historically takes precedence over other considerations once it enters into discussion, and that process has moved commemoration of the victims of the WTC attack to the brink of making innocent civilians, policeman, and fireman into the first front-line casualties of a national battle for survival. As in any similar situation, "the fallen" become sacred to the cause, and deciding upon the appropriate rituals for remembering them becomes a struggle among the social, cultural, religious, and ideological values of those who see themselves as their rightful heirs or spokespersons. Nevertheless, within the diverse group of those who bore the brunt of 9/11/01, there is still no unity about the significance of the losses everyone experienced, because there is still no agreement on what the overarching principles being enshrined really are, not least of them being the substance of allegiance to the principles of the "founding fathers" in a context where civil liberties guaranteed in the Constitution they wrote are being systematically violated in the name of national honor and national self-defense by those in authority who arrogate to themselves "emergency" powers never contemplated by the Constitution's framers.

The cruel reality is that the only deaths that have unequivocal meaning are those of the Al-Qaeda squads who executed the operation. The planners for whom they served as human weapons made a study of the circumstances in which their common adversary—the United States and the secular political and economic model of modernity of which America is, for them, the epitome—could be caught off guard and

profoundly wounded. By fulfilling that plan, Mohammed Atta and his men realized a destiny they had elected, confident that the enormous constituency of disaffected people they hoped to simultaneously address and speak for by their actions would instantly understand and at heart endorse, if not publicly embrace, their ultimate gesture. Their goal was singular, their rationale desperately coherent, and their devotion to it all consuming. That is the totalizing intent and effect of declaring "jihad" against the supposed enemies of Islam.

However, the historical concept of "jihad" lacks a counterpart in our society, despite that fact that in the post-Cold War era there has been no shortage of attempts to impose a comparably simplistic definition of "them" and "us" on the manifest complexity of worldwide modernity, especially when it comes to societies with large Muslim populations. Among the most pervasive and problematic examples of such reductive thinking has been the hypothetical "clash of civilizations" posited by the historian of Arab culture Bernard Lewis and the political scientist Samuel P. Huntington.[3] One need not be a specialist in these fields to find ample reasons to worry about the popularization of their ideas. Nor must one be an international security expert to question the logic and motives behind the declaration of a "global war on terror." Indeed, the sweeping generalizations used to buttress such sloganeering strike many serious observers (and none more eloquently expresses his doubt than the deeply knowledgeable former Under Secretary General of the United Nations for Peacekeeping, Sir Brian Urquhart) as an inherently self-defeating approach to the threat posed to the United States by the wide array of military or paramilitary forces that have at one time or another launched an assault on identifiably American targets abroad or contemplated—and in the instance of 9/11/01 succeeded in—launching such an assault on our soil.[4] To the contrary, the multiplicity of those enemies and their aims precludes any unifying label for them and any unified strategy for dealing with them.

"Terror" is a tactic, not an ideology. Its use does not define any antagonistic community sufficiently to distinguish that community from all others

Drawing I 2005
151 x 102 cm Graphite on paper

Drawing II 2005
151 x 102 cm Graphite on paper

that might take similar actions. This is especially true when we know so many communities that are violently "anti-American" yet do not get along with each other despite nominally shared political, cultural, or religious values. The plural nature of the wars that have been declared against the United States by such communities is indisputable, but the fact that several of these wars merge in the netherworlds of finance and arms trading and have been branded "jihad" does not make them the same war any more than adding the prefix *pan-* to the collective nouns *Arab* or *Islam* has brought those masses who identify themselves as either into harmony with each other, despite the fact that this has long been the dream of fundamentalists of every stripe fighting their "last battle" against former colonial or present neocolonial powers. While Atta and the other hijackers who destroyed the WTC were, in their minds, at war with a country they believed was at war with their faith, it does not follow that defending oneself against them entails engaging in a symmetrical conflict based on crude binaries.

Rather, the asymmetrical nature of terrorism derives partly from the discrepancy that "they" are indeed at war with "us," yet neither "they" nor "we" can be summed up by such a juxtaposition—no matter how hard-line ideologues and opinion-makers on both sides insist on such Manichean distinctions. Outside the domain of propaganda and those enthralled by it, Atta and his cohort do not represent the Islamic world. Nevertheless, their goal was to make a grand gesture that would rally millions of people angry at the United States to an image of its unacknowledged vulnerability. To that end they produced a horrendous spectacle that was intended by them to be photographed, televised, and disseminated by the world's media, starting with the media of the nation they attacked. Which it was.

Employing the most unlikely of means—taking command of a fully loaded aircraft with box-cutters and applying skills learned in commercial flight-training courses—they turned the technology of an advanced industrial society against itself, firstly, by selecting a target built to the structural limits of modern architecture and engineering; secondly, by

Drawing III 2005
151 x 102 cm Graphite on paper

Drawing IV 2005
151 x 102 cm Graphite on paper

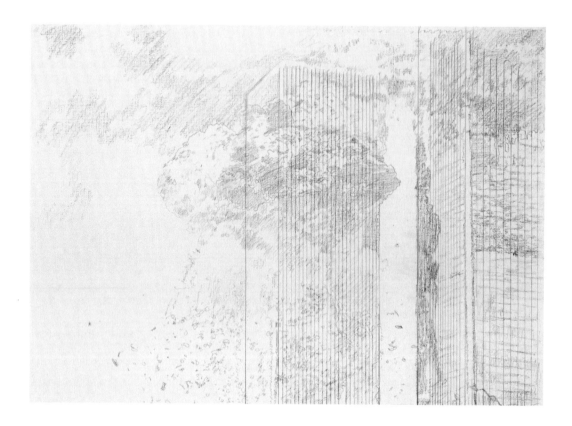

using commercial airlines as bombs; and thirdly, by making certain that virtually everyone on the planet would see what they did within minutes, hours, or, at most, days of their doing it. Strategically, the attacks of 9/11/01 were a stroke of malevolent genius, the leveraging of relative weakness against disproportionate strength, a kind of jiu-jitsu of guerrilla warfare in which the superiorities of the attacker's adversary are used against that adversary. Semiotically speaking, the effective vaporization of a building that proclaimed itself a center, if not *the* center, of world trade, as well as the partial obliteration of another, the Pentagon, which is the headquarters of the world's greatest military power, combined with the global broadcast of the former, resulted in a sudden inversion of symbols never before seen on such a scale or simultaneously by so many people.

Preparatory drawing for *September* 2005
52 x 72 cm

The almost instantaneous reaction to the attacks tested the ambivalent attitudes much of the world's population has toward the United States. And if expressions of sorrow and sympathy were swift in arriving from abroad, equally quick to register were the mixed emotions others felt at watching the emblems of a country they had admired and envied and sometimes loathed from afar brought low by a few well-executed blows. And then, of course, there were those around the world who loudly cheered at such a public humbling of an empire. That cheering has not stopped, and its jarring echoes are perhaps the hardest thing to reckon with for Americans who have always thought of themselves as the benevolent and generous protagonists of modernity, especially when those echoes resound in places that Americans have taken for granted as friendly.

One day in Paris, I met a chic Frenchwoman I know. I noticed that she was carrying a woven grass basket which she said she'd picked up at a market in Pakistan. On it was a stylish folk art design representing two planes hitting the Twin Towers. The woman does not hate America, but neither is she shy about distancing herself from it when she wishes to make a point of her differences with our preconceptions and way of life. Nor, as it turned out, was she immune to a type of schadenfreude that most of her American colleagues would find distasteful, as I myself did since I could not look at the bag's cartoon version of the scene without it triggering my own memories. Was it because of this woman—or rather of the attitude she personified—that French fries were renamed "Freedom fries" during the hysteria that swept America from the aftermath of the attacks, when the President told the world on November 6th, 2001, "You're either with us or against us in the fight against terror?"[5] to the launching of a war in Iraq that was predicated on a bogus link between the far flung aggressions of a network of religiously pious fanatics and the regional ambitions of an Arab Socialist tyrant.

Perhaps; but then, think of the contemporary Afghan rugs emblazoned with schematic renderings of Soviet armaments and portraits of Lenin, Stalin, Breshnev, and the Russian puppet Mohammad Najibullah that chic Americans buy for their floors. The comparison is not between the

systems of government in the US and the former USSR but between the ways in which the gruesomeness of warfare is repackaged as kitsch and savored with cheap triumphalism in places far from the bloodletting.

The irony deeply woven into these rugs is that the "friendly" *mujahideen* freedom fighters who drove the Soviet Union out of Afghanistan with the help of American training and supplies quickly morphed into the "unfriendly" and suddenly incomprehensibly alien religious fundamentalists when the guerrillas turned their weapons on others they viewed as a threat to the integrity of the nation-state they had fought for. The forces the United States had backed against the expansion of Communism included not only indigenous democratic factions but also autocratic warlords and ardent theocrats enthralled by an expansionist Pan-Islamic dream, not the least among them being the former CIA "asset" Osama Bin Laden. However, if such invisible threads of expedient affiliation and predictable disaffection have become the snares embedded in shortsighted policies—"blow back" is the current euphemism of preference—the crux of the difference between how Russians and Americans might regard defeat in the Great Game of Central Asian domination has everything to do with an American tendency to view Russia's extraterritorial engagements as "imperial adventures" while refusing to view its own forays into other countries in the same terms.

Meanwhile, the profound shock Americans experienced on 9/11/01 and the psychic tremors that continue to shake the country stem in large measure from perspectives that view the United States as a permanent exception to historical forces and vulnerabilities. For few Americans besides veterans or those who have fled to this country from other zones of conflict have participated in or seen war up close. Moreover, not since the Vietnam War have Americans been mocked while licking their wounds, and never before have the wounded been the man and woman on the street.

Some of what seemed to be mockery but was not necessarily intended as such resulted from reflex responses to the purely spectacular aspects

This and following pages, to p. 39

October 18, 1977
(18. Oktober 1977) 1988
Oil on canvas

Cycle of fifteen paintings

of the attack. They were a product of a saturation of the senses and an evacuation of common sense that is all too familiar in the media age. They also stemmed from an aesthetization of violence that conflates art and life in ways that only the glib, the cynical, or the supremely detached can imagine. Such was the reaction of the German avant-garde composer Karlheinz Stockhausen, who notoriously proclaimed the fall of the Twin Towers "the greatest work of art that is possible in the whole cosmos."[6]

On one hand, the recognition that solidarity with the United States in its moment of crisis was not universal profoundly upset many Americans, and it further exacerbated inward-turning nationalism in some sectors of the population. Such nationalism took one of its most extreme forms in commentary by the far-right-wing firebrand, Ann Coulter.

> This is no time to be precious about locating the exact
> individuals involved in this particular terrorist attack. Those
> responsible include anyone anywhere in the world who smiled
> in response to the [9/11 attacks]…We should invade their
> countries, kill their leaders and convert them to Christianity.
> We weren't punctilious about locating and punishing only
> Hitler and his top officers. We carpet-bombed German cities;
> we killed civilians. That's war. And this is war.[7]

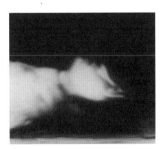

On the other hand, America's status as a country that had not previously experienced a cataclysm like the one that occurred on 9/11/01, and an attack on the chauvinism that once attended its now shattered sense of "exceptionalism" were, if anything, a provocation to people who felt that the United States was at last beginning to learn the hard way what they themselves had long since been forced to learn. (Stockhausen, who was in his teens when the Allied saturation bombing of Germany took place, seemed to have forgotten the lesson, or sublimated it in an inexplicable and apparently uncomprehending dandyism.)

In the grip of contradictory impulses and responses, shock and amazement, anger and hurt, the desire to ascribe a fixed, collective significance to the events of 9/11/01 was frustrated from the outset. Instead, various degrees of alienation from the rest of the world and anxiety within that isolation seized hold and stretched emotions and attitudes to the outer reaches of most Americans' experience and tolerance. Which then snapped back, often suddenly, often irrationally.

The furor over Susan Sontag's *The New Yorker* magazine essay on the disparity between the wild but all too predictable declarations of many American leaders and the new situation with which we were brutally but undeniably confronted on that fateful morning is symptomatic of such a retreat from reality into rhetoric. Prior to quoting Sontag, I would like to underscore the last lines of this passage and note that the view she espoused and for which she was vilified by the "patriotic" press was the previously cited judgment I heard from a World War II veteran—my father—a week before her words were published.

> The disconnect between last Tuesday's monstrous dose of reality and the self-righteous drivel and outright deceptions being peddled by public figures and TV commentators is startling, depressing. The voices licensed to follow the event seem to have joined together in a campaign to infantilize the public. Where is the acknowledgement that this was not a "cowardly" attack on "civilization" or "liberty" or "humanity" or "the free world" but an attack on the world's self-proclaimed super-power, undertaken as a consequence of specific American alliances and actions? How many citizens are aware of the ongoing American bombing of Iraq? And if the word "cowardly" is to be used, it might be more aptly applied to those who kill from beyond the range of retaliation, high in the sky, than to those willing to die themselves in order to kill others. In the matter of courage (a morally neutral virtue): whatever may be said of the perpetrators of Tuesday's slaughter, they were not cowards.[8]

The heated condemnation of Sontag's skeptical essay was a harbinger of the rapid politicization of 9/11/01 and the scramble to claim it for conservative causes in the early phases of George W. Bush's first term as President. That rush to judge the patriotism of people and their position on "the war against terror" by their inferred attitudes toward what had happened that day did not spare Gerhard Richter or his work.

The target of opportunity was the inclusion of his cycle of paintings *October 18, 1977* (1988) in a retrospective of the artist's work, *Gerhard Richter: Forty Years of Painting,* that opened at the Museum of Modern Art in October 2002, which was just over a year after 9/11/01. Once again I must step forward rather than back, because the polemic that arose when the paintings were shown focused directly on me as the curator of that show and author of the catalog, as well as of a separate monograph on the cycle. It was not the first time since these paintings were initially presented in Germany, that intense controversy had flared up, however the nature of this incendiary outburst was distinctly American and a key to the temper of the times, given that the same group was shown at MoMA without any such furor in 2000, several years after the museum had acquired them.

The *October* paintings concern the violently contradictory lives and the mysteriously violent deaths of members of the so-called Baader-Meinhof group—the most notorious cell of the Marxist Red Army Faction (RAF)—which operated as an armed guerilla band in West Germany from 1970 to 1977 with survivors and spin-offs continuing their activities into the next decade. Ulrike Meinhof, one of the two leaders, came from a family that had been anti-Nazi during the war. She herself had become a pacifist student organizer and journalist during the Cold War of the 1950s and 1960s. Her gradual drift into revolutionary Marxism and precipitous plunge into revolutionary terrorism fascinated and disturbed Richter. Born only two years before her, the artist had experienced both the Hitler era, during which he was a schoolboy and his family was largely pro-Nazi, and East German communism, during which he came of age as a young socialist realist painter, from a very different

vantage point than Meinhof. In her and her tiny cohort, Richter identi-fied an example of radical idealism gone horrifyingly wrong. In essence, his subject was not so much the Baader-Meinhof group per se as the existential causes and consequences of ideology. Asked in 1989 if he had sympathy for the RAF's politics, Richter replied that his own position was far from theirs:

> I have always rejected it as an ideology, as Marxism or the like. What interests me is something different, as I've just tried to say: the why and wherefore of an ideology that has such an effect on people; why we have ideologies at all; whether this is an inevitable, a necessary part of our make-up—or a pointless one, a mere hindrance, a menace to live, a delusion…[9]

He went on to say that the same "overriding, ideological motivation," produces "tremendous strength, the terrifying power that an idea has, which goes as far as death. That is the most impressive thing, to me, and the most inexplicable thing; that we produce ideas, which are almost always not only utterly wrong and nonsensical but above all dangerous."[10]

Thus, for Richter, the tragic, self-deceptive extremism of the Baader-Meinhof episode was symptomatic of the larger tragedy of totalizing ideology in twentieth-century Germany. But as important to history and as bitter for him as those self-deceptions were, Richter remained determined not to forget the humanity of the people who succumbed to them. The *October* cycle shuns any celebration of RAF's actions just as it eschews criticism of those actions. What it commemorates with the heaviest of hearts and the fewest illusions is the failure of the postwar generation to come adequately to terms with the profound wounds inflicted on them and the horrendous burden left behind by the genera-tions of the Third Reich and Soviet-style Socialism.

Meinhof's counterpart Andreas Baader, Baader's lover and collaborator Gudrun Ensslin and their comrade Jan-Carl Raspe died under obscure circumstances in Stuttgart's Stammheim Prison on the night of October 18,

1977. Their deaths were officially ruled as suicides, although many people suspected state-mandated murder, despite the fact that the earlier demise of Meinhof and of another member of the group, Holger Meins, who starved himself, are not in doubt. In 1988, a decade after the grim finale in Stammheim, Richter began a series of fifteen grisaille pictures based on mass media and forensic photographs and video footage of the events.

When the series was unveiled at the Museum Haus Esters in Krefeld in 1989, it sparked a firestorm of criticism from both the Left and the Right. Predictably, the Right charged Richter with overtly celebrating Communists with blood on their hands, even though he had left the Communist East to come to the West in 1961 and had never expressed support of any kind for Baader-Meinhof group's militancy while they carried on their insurrectionary underground campaign as many other artists and intellectuals had done. Offering proof of Richter's distance from their politics, the Left vociferously disputed the artist's "right" to portray their martyrs. In ways that are unexpectedly congruent with some of the controversies around the commemoration of 9/11/01 that I have referred to above, the Left essentially claimed the entire legacy of the Baader-Meinhof group for itself—including both the existing pictorial archive and the freedom to make new pictures—while the Right found it impossible to accept that anyone who was not an enemy of society as a whole could take an interest in those who had declared themselves implacable enemies of the State.

Equally inflammatory was the conclusion of an op-ed piece about the 2002 presentation of Richter's cycle that appeared in *The Wall Street Journal* on March 1 of that year. The author, Eric Gibson, was a regular contributor to such mainstream art glossies as *ARTnews* and *Sculpture* magazine and also wrote for the neo-conservative monthly *The New Criterion,* which has long specialized in questioning the integrity—if not the patriotism—of those on the opposite side of the "culture wars" with whom its critics disagree. On the editorial page of the *Journal,* Gibson outdid himself. His charge is predicated on quotations taken out of context, carefully abbreviated or otherwise reshaped to alter their meaning.

Although too long to cite in full, here is the essence of that charge:

Sometimes art and life intersect in inconvenient ways, never more so than when the subject is terrorism.

New York's Museum of Modern Art has just opened *Gerhard Richter: Forty Years of Painting*, a retrospective of a notable German contemporary artist. The show was organized by Robert Storr, the museum's senior curator of painting and sculpture. It includes nearly 200 works, but one is of special interest just now.

October 18, 1977, painted in 1988, is a suite of 15 pictures whose subject is the Baader-Meinhof Gang, the 1960s radicals who constituted what was a German version of the Weather Underground, only worse...

For his work, Mr. Richter drew on black-and-white news photos of the terrorists' capture, their prison cells, their dead bodies and their funeral... Though he himself has been careful in his public statements not to endorse the Baader-Meinhof Gang—or condemn it—it is almost impossible to see *October 18, 1977* as anything but a series of martyr paintings, particularly given the claims circulating at the time that the three terrorists were not suicides but the victims of murderous authorities.

Two years ago, MoMA acquired *October 18, 1977*, displayed it for three months and published a catalog written by Mr. Storr. One would think that whatever vestigial aura of romantic rebellion that once hovered over the gang or other 1960s revolutionaries was blown away on Sept. 11, when the brutality of terrorism hit home.

And yet... At the press conference for the current show, a questioner asked how Sept. 11 had changed the meaning of

October 18, 1977. Here is Mr. Storr's reply:

"If you consider how the people involved in the attack on the World Trade Center were characterized when it first happened, as if they were unknowably strange—fanatics that we could somehow not fathom their thinking—and then you realize, in fact, that some of the people involved were middle-class, relatively speaking, educated people who, out of desperation, out of anger, did horrific things … then one of the things that the paintings represent [that] should be present in our thinking about current events … is that we are not dealing with monsters, we are not dealing with people we do not know; we are dealing with people very much like ourselves."

Talk about moral equivalence! What kind of mind is it that, at this stage of the game, refuses to distinguish between good and evil, between civilization and barbarism, and falls back on a parody of inclusiveness—"people like us," driven by "desperation" and "anger"—to explain an atrocity like Sept. 11? Perhaps it takes a mind that is still in thrall to the revolutionary ethos of the 1960s counterculture…

[Storr] can't categorically condemn the Sept. 11 terrorists because that would be a judgment on the Baader-Meinhof Gang too, terror being indivisible. He can't condemn them because doing so would amount to an indictment of the 1960s student movement as a whole. And that would be an act of apostasy too awful for Mr. Storr even to contemplate.

In 2001, terrorists murder 3,000 of his fellow citizens in his own backyard. But all that really counts for Mr. Storr is keeping alive the delusions of 1968.[11]

I will not waste time here defending myself against the unsupported claims and calumnies of an attack on me made almost ten years ago,

except to say that as someone on the Left I have opposed the use and romanticizing of violence before, during, and after 1968 and that I have condemned and do condemn the course taken by the Baader-Meinhof group, the Weatherman and all the others of their ilk who steered necessary but peaceful activism into the dead-end of extremism and brutality. The reason for underscoring how easily "people very much like ourselves" become extremists is to underscore how easily they slip into violence. It is crucial that we keep that process in mind if we ever hope to understand terrorism. In recent years, popular culture seems to have outstripped pundits like Gibson in presenting such paradoxes to the general public, so that films like the political thrillers *Syriana* (2005) and *The Traitor* (2008) and serious novels like Mohsin Hamid's *The Reluctant Fundamentalist* (2007) have managed to portray the temptations of terrorism currently alive in the Muslim world through complex characters rather than through demons that caricature entire cultures and causes.[12]

The purpose of retrieving Gibson's hysterical misconstruction of my words and his equally flawed reading of the *October* cycle is to demonstrate the continuity of reductive thinking about terrorism against which Richter's *October* cycle was pitted, and by which interpretations of *September* may be clouded. Contrary to Gibson's assertion, terror is not indivisible. Moreover, to observe that idealists sometimes devolve into destroyers is not to create a "moral equivalence" between those who might kill and those who actually do, or to refuse to "distinguish between good and evil, between civilization and barbarism."

Nevertheless, paintings Richter made in one context—a divided postwar Germany where years of ideological polarization had put certain subjects off limits to serious scrutiny and frozen people into permanently antagonistic positions on issues where scant factual certainty and no clear consensus in terms of interpretation or judgment about key points of contention existed—became emblems of a very different but comparably polarized context. That new context was the United States in the aftermath of the first armed assault on its territory in generations, a place

where the main criteria for public discourse about that assault were being reduced to a loyalty oath, even as that assault's far-reaching ramifications were just beginning to be glimpsed and its true origins were just becoming known, not the least of those revelations being the Bush administration's utter failure to prepare for or prevent an attack it had been warned by intelligence sources was imminent.

For over fifty years, starting with the decolonizing of Algeria and the bombing campaigns of the French paramilitary OAS and the Algerian revolutionary FLN (both of which killed civilians in considerable numbers), Western democratic societies have had foreign and domestic terrorists periodically staring them in the face. But they have also had the metamorphic, metastatic specter of Terror on the brain, the latter signaling the broad propagandistic and political impact of the more limited outrages of the former. At least twice, Richter has made terrorism his explicit theme. The first time was in *October 18, 1977* (1988). The second is in *September* (2005). Why? And if I have accurately sketched the meaning of the multipart *October* cycle here and done so in greater detail in previous essays, what is the meaning of a single, small, almost abstract depiction of one of the most consequential occurrences in recent world history?

1

In 2002 Magnum photographer, Gilles Peress, and Charles Traub, head of the photography program at the School of Visual Arts, mounted an exhibition of photographs taken by eyewitnesses called *Here Is New York* at a storefront on Prince Street in downtown Manhattan, only blocks away from the site of the former World Trade Center. Anyone who had digital files of their images could scan them, print them, and install them in the gallery. All were sold for $25.00 a piece, with the proceeds going to assistance for the victims of the attack and the agencies that gave them relief. Under the direction of the Chief Curator of Photography, Peter Galassi, the Museum of Modern Art organized an exhibition entitled *Life of the City*, which included a slide show of the pictures from *Here Is New York*; and prints of 500 of them were eventually donated to the Museum. For a lively journalistic account of this "democracy of pictures" see, *Watching The World Change: The Stories Behind the Images of 9/11* by David Friend (Farrar, Strauss and Giroux, New York, 2006).

While little important art based on the attack on the World Trade Center has been produced other than Richter's *September*, one of the most thought-provoking attempts at accounting for the clash of responses to the catastrophe that has appeared so far is "comix" master Art Spiegelman's *In the Shadow of No Towers*, (Pantheon, New York, 2004.) A typically polysemic mix of visual gags, quotations from the classics of the medium, anxious autobiography and world-weary ambivalence, the book weaves together many of the themes in this essay but in different patterns and to different effect. All who watched the towers fall are faced with the same conundrums and will continue to puzzle over them for years to come; what each of us makes of or out of them is as various as our viewpoints and our means. Still, the opening lines of Spiegelman's introduction should echo in the hollowed-out consciousness of many eye-witnesses: "Minor mishaps—a clogged drain, running late for an appointment—send me into a sky-is-falling tizzy. It's a trait that can leave one ill-equipped for coping with the sky when it actually falls. Before 9/11 my traumas were all more or less self-inflicted, but out-running the toxic cloud that had moments before been the north tower of the World Trade Center left me reeling on the fault line where World History and Personal history collide."

2

This account of the man trying to "turn off" reality comes from the photographer and filmmaker Tomer Ganihar who was on site taking pictures.

3

See "The Clash of Civilizations?" by Samuel P. Huntington *Foreign Affairs*, Summer 1993, as well as the post 9/11/01 essays and books of Bernard Lewis.

4

Pertinent essays by Sir Brian Urquhart covering foreign policy issues, as well as reviews of books on the United Nations, the Bush administration, and the wars in Kuwait, Iraq, and Afghanistan and relations between the United States and Middle Eastern countries have appeared regularly in the *New York Review of Books*.

5

George Bush addressing an antiterrorism summit in Warsaw, as reported by CNN, November 6, 2001. "Bush said Tuesday that there was no room for neutrality in the war against terrorism. 'A coalition partner must do more than just express sympathy, a coalition partner must perform,' Bush said. 'That means different things for different nations. Some nations don't want to contribute troops and we understand that. Other nations can contribute intelligence-sharing… But all nations, if they want to fight terror, must do something.' Bush said he would not point out any specific countries in his speech. 'Over time it's going to be important for nations to know they will be held accountable for inactivity,' he said. 'You're either with us or against us in the fight against terror.'"

6

Of 9/11/01 Karlheinz Stockhausen said:
"Well, what happened there is, of course—now all of you must adjust your brains—the biggest work of art there has ever been. The fact that spirits achieve with one act something which we in music could never dream of, that people practice ten years madly, fanatically for a concert. And then die. [Hesitantly.] And that is the greatest work of art that exists for the whole cosmos. Just imagine what happened there. There are people who are so concentrated on this single performance, and then five thousand people are driven to Resurrection. In one moment. I couldn't do that. Compared to that, we are nothing, as composers. […] It is a crime, you know of course, because the people did not agree to it. They did not come to the 'concert'. That is obvious. And nobody had told them: 'You could be killed in the process.'"

Stockhausen is not the first major artist to have played the idiot in matters outside his expertise. Yet inasmuch as his dismal misreading of both history and art history speaks for itself in this case, it is emblematic of more pervasive confusion. If there is any positive side to such foolish remarks, it is the manner in which it exposes that wider confusion and provides the basis for challenging the conflation of one kind of reality with another that is fundamentally unlike it except by virtue of superficial verbal comparison.

The statements of Nobel Prize Laureate Dario Fo, reported in the *Frankfurter Allgemeine Zeitung* on September 25, 2001, had been published in a circular letter and will be no less difficult for most Americans to read. But harsh as they are, it is necessary for Americans to be aware of such sentiments if they want to achieve a realistic estimate of their place in the world. At least Fo refrained from fatuously equating shock tactics in art and those in politics as Stockhausen had done. "Big speculators joyfully splash about in an economy that lets millions of people die every year in misery. What are 20,000 dead in New York by comparison?... Regardless of who carried out the massacre, this violence is the legitimate daughter of the culture of violence, hunger and inhumane exploitation."

In comparison to these remarks, consider Richter's own thoughts about the simultaneous attractive and repulsive qualities of New York, which for him, as for many others, has epitomized America's ascendancy in the last century. The city's embodiment of modernity was and still is, in varying measure, both thrilling and off-putting to those who observe it from a distance and/or occasionally come to take a closer look. In recent years Richter has traveled fairly frequently to the United States for exhibitions in various parts of the country and has stayed for more or less extended, though never very lengthy, periods in New York for the same reason. A diary entry entitled "New York, 6 September 1984," vividly illustrates the extremes and complexities of his attitudes toward New York at a time when his professional star had begun to rise in America but when postwar era memories of the gap between it and his more intimate experience in Germany were still fresh.

"The more the city fascinates me, the more I suppress the over-whelming rage and hostility that I feel towards this city, in all its magnificence, modernity, beauty and above all its incompatible, unmatched vitality, which are denied to me, and which I can only admire, full of envy and raging impotent, hateful jealousy (as a Cologne, Düsseldorf, Dresden man); this city of the elect and the privileged, of wielders of power and decision-makers, which implacably raises up and destroys, produces superstars and derelicts; which is so merciless and at the same time so beautiful, charming, dreamlike, romantic, paradisal [sic]. The city that exerts such a deadly fascination; the city that has killed many others besides Palermo. This city, this monster, with its tall old buildings that seem so familiar and cosy and convey such a sense of security. I envy New Yorkers, and I think with discontent of Germany, the stifling fug of its society, its affluent philistinism, its all-smothering, oppressive ugliness. I shall rebook tomorrow and fly home early."

Gerhard Richter—Writings 1961–2007, p. 133.

7

Ann Coulter quoted in "Is Right-Wing America Becoming Fascist?," *Adbusters,* May/June 2006, n.p.

8

Susan Sontag in *The New Yorker,* September 24, 2001. It is important to note that the bombing referred to in this statement was engaged in before the United States declared war on Saddam Hussein.

9

Richter in Conversation with Jan Thorn-Prikker, in *Gerhard Richter—Writings 1961–2007,* edited by Dietmar Elger and Hans Ulrich Obrist, D.A.P./Distributed Art Publishers, New York, 2009, p. 232.

10

Ibid.

11

Eric Gibson, "A Fuzzy View of Terror," in *The Wall Street Journal,* 1 March 2002 W11.

12

No American has yet produced a work of sophisticated popular culture and political critique on the subjects of empire and terror that is as unblinking, as searing, as complex and as "objective" as Gillo Pontecorvo's *The Battle for Algiers* (1966)—that complexity and "objectivity" being part of the reason that it is used for training by the American counterinsurgency forces, as well as the reason that it was banned for years in France after the loss of Algeria.

Among the most remarkable achievements of *The Battle for Algiers* was the inclusion of subtly telling details that give human dimensions to the members of the terrorist cell of the FLN around which the story centers, notably the reaction of its women members to the requirement that they wear Western dress so as to be able to pass amidst the stylishly modern colonials in the French quarter of the city where they plant their bombs.

That contemporary terrorists from the Muslim world have often been disaffected but well-educated members of the already modernized middle or upper classes of their respective countries and not grotesquely atavistic representatives of incomprehensibly alien societies is made inescapably obvious by attention to the backgrounds of the would-be Christmas bomber of 2009, Umar Farouk Abdulmutallab, son of a wealthy Nigerian banker, of the would-be Time Square bomber of 2010, Faisal Shahzad, a naturalized U.S. citizen born in Pakistan who held an MBA from an American university, and of course Osama Bin Laden himself, the once worldly son of one of the richest private citizens in Saudi Arabia.

Chapter 4

Now let us examine the picture closely. And while studying it, let us keep squarely in mind the fact that the direct scrutiny of images is as contingent and as variable in the information it provides as the direct scrutiny of events. No one sees exactly the same thing when they look at the same thing because each viewer comes to the work differently prepared to look and does his or her looking under different perceptual, cultural, and historical circumstances, whether or not the work itself ever moves from one place to another. Moreover, let us not lose sight of the fact that not only does the routine reproduction of images deplete what Walter Benjamin called their "aura"—which, contrary to the pervasive notion that aura is a golden glow that masterpieces magically acquire in churches, stately mansions, or museums, consists instead of the vital radiance apprehended by each individual spectator who is alert to a work's contingent phenomenological state—in the case of paintings based on photographic sources, reproduction effectively erases through further photomechanical reprocessing every detail or anomaly of their surface, color, tone, and touch peculiar to the original. In short, it homogenizes all the bits of painterly data that the painter has labored to introduce into or artfully elide with the purely pictorial content provided by that photo source. There is no better demonstration of this effect than in the reproduction of *September* (2005). Although an inadequate substitute for what has been visually removed, verbal description functions as a means of partially restoring those deficits, or at any rate of posting a warning that they exist lest those who have only catalogs and computer images to consult underestimate the subtlety and complexity of the nearly monochrome canvas and draw the wrong conclusions from it.

Physically, *September* belongs to a fairly sizable body of work Richter has created over the last decade or so, pieces that at a distance resemble gray smudges. Some of these paintings are large, but most are of moderate to

small dimensions, *September* being in between the two lesser proportions. That scale places it in the range of many of the media images people saw on television at the time of the attack and since, while also countering the tendency in history painting of representing major events in rhetorically big formats with melodramatic effect. Furthermore after having initially rendered the full explosive power of the hijacked planes' collision with the skyscraper in bold tones and colors Richter felt defeated as an artist by the failure of his work to measure up to the vividness direct photographic documentation of that collision achieved. Demoralized by this discrepancy Richter contemplated destroying the painting altogether and in 2005 went so far as to tell a reporter from *Der Spiegel* who visited his studio and saw the canvas in its original state over the artist's day bed that he was intending to do so, or, as is his economical habit, just paint over the image on the way to making an abstract picture.

Of the modestly scaled gray paintings which *September* partially resembles, some are densely painted and the rest more lightly painted with *September* being perhaps the most sparsely painted of all. Although it was executed in several layers only two now show on the surface. The first is a sheer, semiporous skin of mottled pigment that covers the entire canvas, except where it has been scraped or rubbed off, exposing the white primer underneath and the nap of the linen underneath that. Atypically, for a Richter painting, those canceling strokes lift off the initial coat, stop short of the outer margins and round out well inside of them, rather than running straight across the surface and so subtly reinforce the centrality of image. This effect was accomplished one evening with a knife rather than with Richter's customary squeegee or spatula. He had been contemplating the painting for several days before deciding that such a tool might be a solution to the problem. Nothing in the artist's work is routine no matter how consistent some effects may superficially appear to the casual viewer, not even the choice of a painterly "eraser."

It is important, though, that the overall impression is roughly that of a drumhead, stretched evenly over the support without any gaps at the edges so that the field of vision is taut and roughly uniform in tone and

texture. As a result, anomalies and nuances that do exist read clearly as being in tension with the overall consistency of the pictorial space and of Richter's touch. The second layer consists of streaks, smears, and clots of pasty pigment whose tonal range is generally broader than the undercoat and extends from milky grays and blues to creamy anthracite aureoles. These impasto passages traverse the rectangle in opposite directions, going from left to right in the upper half of the picture and from right to left in the lower half. That sense of contrary motion pulls at the surface and, in painterly terms, functions like "speed lines" in cartooning—but speed lines that emphasize contrary forces, or possibly a single force pushing out this way and that. Aside from this animating effect, the heavier paint serves, on the one hand, to stress the canvas's immediate tactility and objectivity, and, on the other, simultaneously accents and indexes the near dematerialization of the thinner layer and of the primary image just barely bodied forth within it.

That image is faintly perceptible in the contrasting grays that dominate the canvas and in the faint blush of color that grows stronger as the viewer approaches, allowing the eyes to acclimate to the dim light that imbues the picture; for despite first appearances, it is a picture and not one of Richter's monochrome abstractions, a *Bild* and not an *Abstraktes Bild*. The most visible contrast is between the predominant grisaille and the pale cobalt blue zones that fill the left-hand side and central column of the image. For the rest, tones and tints permeate each other while patches and tiny nodes of white percolate throughout in what may initially seem to be a quasi-photographic dissolve, but which, to the viewer's dreadful amazement, instead depicts an entirely physical one.

That such a realization takes time is owed to the fact that the image is at the very edge of being recognizable, at that liminal point where the information it contains could be read any number of ways and the mind must struggle to create a whole, or pictorial Gestalt, out of the diffuse, ill-defined contours of the forms and the apparent coding of the color. In sum, viewers must mentally reconstitute a likeness that is in effect disintegrating before their eyes. In that way, the processes of wet-into-wet

Inpainting (Gray)
(Vermalung (grau)) 1972
250 x 250 cm Oil on canvas

oil painting and Richter's long-standing practice of inpainting (*Vermalung* in German) his pictures suck viewers into the vortex of the undoing of the image and thus into the destruction of the WTC, for that is what they are looking at: the explosion of United Airlines Flight 175 from Boston as it slammed into the South Tower.

The more time spent with the painting the more fully that terrible knowledge dawns on the viewer. And the more easily that viewer will come to see that the grays and blues in the middle of the canvas are blended with brown flecked by muted red, yellow, and orange highlights, traces of which can also be found in the lower left-hand side of the image, like flying sparks that glow hot in the oxygenated atmosphere before they burn out and become cinder. That oblong zone of warm tones amidst the cool grays and blues and those sparks are the exploding airplane. And as we know from such images, the charred particles that filled the air around the towers and then blew across the city were not only the byproduct of vaporized fuselage and building materials but in large part the precipitate of some two thousand seven hundred and fifty-two lives, such that the air those present inhaled was in some immeasurable proportion composed of the last vestiges of those who had been incinerated at the site.

Again I must step forward, because such a macabre thought might not occur to anyone who wasn't there, to anyone who has only looked at the pictures disseminated by the news media. Yet, while seldom talked about, it was a thought in the back of the mind of almost everybody who breathed the air on that day and in the weeks after. The smell of burning bodies was masked by the smell of burning plastic and other inorganic substances, but one knew that the nauseating scent was a composite including the odors of a crematorium. Pictures have no smell, but in a synesthetic sense, Richter's rendition of 9/11/01 has the taste of ashes. To be sucked into this picture also entails breathing its atmosphere.

At the risk of taking the idea of synesthesia to the point of objectionably aestheticizing a charnel house, I would add that Richter's familiar way of blurring his images in this case adds to our understanding of the subject he

has chosen to paint from a distance by opening meaningful gaps between us and the onsite images we know so well that we may have stopped thinking about them, and, more importantly, that we may have stopped allowing ourselves to engage emotionally. To paint a suffocating, carnally polluted cloud over the silhouettes of the Twin Towers is one method of evoking the all-encompassing, all-consuming deathliness of the event. And for those who were there but out of self-protection have suppressed the memory, it is perhaps a way of reconstituting it. To drag a dirty scrim across the image also takes the image out of contention as a "realist" picture, that is, as a reliable purveyor of fact or, for that matter, as the vessel for facts whose precise correlation can be questioned or challenged as interpretations. *September* states nothing. Unlike *October 18, 1977,* not even the date implicit in the title, September 11, appears in full, although it has sometimes been referred to by that misnomer. This is a figment rather than a record of history. Compared with what eyewitnesses can recall even with the passage of time and what video and photography have captured and preserved, Richter's version—or, better said, vision —of 9/11/01 is an eroded representation of a monument blown to smithereens, the ghost of a ghost.

top left: Robert Capa,
*Loyalist Militiaman at the
Moment of Death, Cerro
Muriano, September 5, 1936*

top right: Edward T. Adams,
*General Nguyen Ngoc Loan
Executing a Viet Cong Prisoner
in Saigon*, 1968

Among the first dimensions of reality—and of documentary art's standard claims to truthfulness—that is erased by Richter's painterly methodology is time itself. Along with it goes the photographic fiction of "the decisive

moment" that encapsulates the essence of the people and things arrested by the camera's shutter. Of course, the streaming of film and video images has long since undermined that idea, though movie freeze frames and stop-action images or instant-replay digital sequences have partially sustained the notion at the level of forensic data. Here is the moment when it happened; the moment when Kennedy died in his Dallas limousine, or the moment when his accused assassin Lee Harvey Oswald took a bullet in a Dallas jail. But as these very examples argue, such images prove nothing. Moreover, with or without subscribing to conspiracy theories even the most credulous person studying these pictures is aware that the truth of those events does not reside in their grainy details. Neither does the truth of 9/11/01 lie in any of the pictures taken that day; and much less is it distilled in any single picture. Richter's blur makes that flux and indeterminacy explicit. Once we have figured out that his painting focuses on the South Tower when United Airlines Flight 175 hit, once we confirm that the initial impact was at 9:03AM, and even after searching for the source image and ascertaining when it comes in a sequence of images, we still cannot pin down the exact second being portrayed.

For gruesome comparison, take Robert Capa's "decisive moment" photograph, *Loyalist Militiaman at the Moment of Death, Cerro Muriano, September 5, 1936,* or Eddie Adams's Pulitzer Prize-winning photograph, *General Nguyen Ngoc Loan Executing a Viet Cong Prisoner in Saigon* (1968). Both these images purport to represent the instant in which an individual dies at the hand of another, and the latter one shows the hideous intimacy of that shared moment. Richter's painting does no such thing, even though we know that the hijackers of 9/11/01 and their victims died simultaneously. Collective death cannot be seized by the camera and presented to the viewer as the dramatic climax of a conflict. The blast of a bomb destroys many things, among them all possibility of narrating individual fates.

This may in part explain the horrid fascination of the pictures we do have of people who leapt to their deaths from the Twin Towers, for in

those wrenching pictures individuality and the existential finitude of time is meaningfully incarnated by the postures and gestures of the doomed. Weapons of mass destruction do indeed exist, but it would seem to be beyond the ability of most human beings—at any rate, it is beyond my ability—to vicariously contemplate death when it has no face, no body, no uniqueness. History tells us that this is why the majority of those who orchestrate mass murder are able to do their job, to drop bombs on invisible populations so as to make them disappear definitively. Only the hardest, cruelest, most instinctually detached of men or women can kill large numbers at close range.

Richter's blurring of the explosion in the South Tower places gratifica-tion of any desire to see and thereby seize death pictorially beyond the viewer's reach. It is painting's rejoinder to a photographic myth; painting's discretion counteracting the camera's voyeurism. Much has been written in recent years about the motives and morality connected with photo-graphically depicting violence and suffering, David Levi-Strauss's *Between the Eyes: Essays on Photography and Politics* and Susan Sontag's *Regarding the Pain of Others* being just two examples. I will not go into that literature here, except to suggest that throughout his career Richter has been asking such questions in relation to his own medium-conflating artistic practice and to that extent his work constitutes a corpus of critical thinking to which all discussions of these matters should refer. In his case, reticence, specifically the decision not to paint what "cannot be painted," is the principal means of critique.[1] *September* is the signal test of that criteria and the signal demonstration of Richter's principles. Yet for Richter, the highest aesthetic plane is the terrain in which the ravages of the lowest states of the human condition can be made most piercingly visible. To exquisitely paint an indescribably ugly subject is not to glamorize something inherently odious but rather to call attention to it by showing tenderness toward something that has been visited by brutality, and so make it harder if not impossible for the viewer to turn away from the image once its subject has been recognized. To paint that image in such a manner as to short-circuit its sensational charge and deny voyeuristic gratification in the spectacle that charge transmits

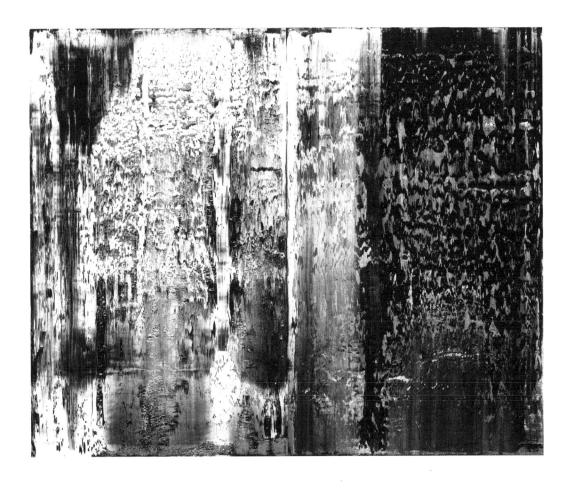

is to use the most sophisticated artifice to render the simple, absolute, but always elusive reality of human suffering. This has been the formal predicate for all of Richter's artistic meditations on war and terror. Thus, he has written:

> Art has always been basically about agony, desperation, and helplessness. (I am thinking of Crucifixion narratives, from the Middle Ages to Grünewald; but also of Renaissance portraits, Mondrian and Rembrandt, Donatello and Pollock). We often neglect this side of things by concentrating on the formal, aesthetic

January
(Januar) 1989
320 x 400 cm Oil on canvas

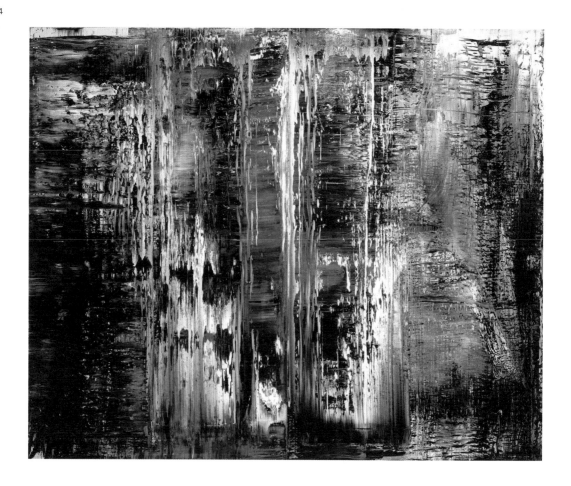

side in isolation. We no longer see content in form ... the fact is that content does not have a form (like a dress that you can change): it is form (which cannot be changed.) Agony, desperation, and helplessness cannot be presented except aesthetically, because their source is the wounding of beauty (Perfection.)[2]

Specifically, agony, desperation, and helplessness exploded in the horrible wounding of a fine fall day. Richter flayed a delicately painted picture of that aggression so as to render the trauma not only visible but palpable.[3]

Speaking about the genesis of *September* to Hans Ulrich Obrist who, during the last decade, has become his most frequent interlocutor

December
(Dezember) 1989
320 x 400 cm Oil on canvas

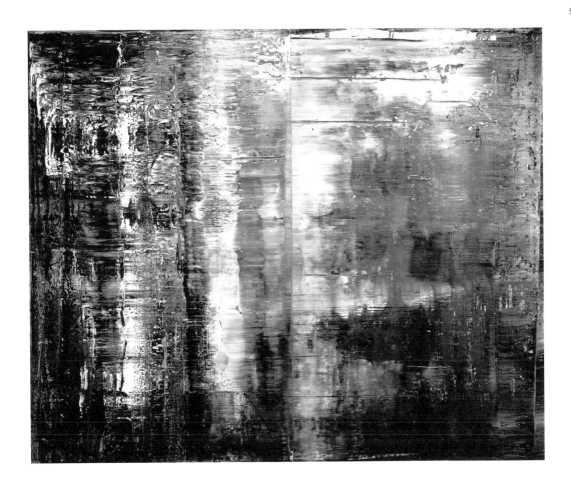

(replacing Benjamin Buchloh in that capacity), Richter compared the painting with an earlier suite of pictures painted in 1989 that commemorated the month that Communist authorities opened the wall between East and West Germany—November 9 being the exact date—and the months following, during which the wall was gradually demolished and the process of reunification initiated:

> Apart from the elegant *December, November, January*, which have more black. The new pictures are more spontaneous, more abrasive, less aesthetic, somewhat painful. The little picture of the two towers was very colorful to start with, with the garish explosion beneath the wonderful blue sky and the

November
(November) 1989
320 x 400 cm Oil on canvas

Firing Squad
(Erschießung) 1962
170 x 200 cm

Front garden of Galerie Parnass
in Wuppertal, Germany, 1964

Front garden of Galerie Parnass
in Wuppertal, Germany, 1964

Mr. Heyde
(Herr Heyde) 1965
55 x 65 cm Oil on canvas

flying rubble. That couldn't work; only when I destroyed it, so to speak, scratched it off, was it fit to be seen.[4]

The "new pictures" to which Richter was referring were a series of twelve abstractions of a generally dark, and, in his own words, "abrasive" cast though it is hard to see *January, December, November* (usually presented in reverse chronological order) as being in any sense "aesthetic" to a fault. To the contrary, they are a remarkably somber counterpoint to the jubilation that was typical of officially sanctioned reunification symbols. Having viewed the "economic miracle" and cultural contradictions of the Federal Republic of Germany in the West with the same scepticism that he had toward the unfulfilled utopianism of the German Democratic Republic in the East, Richter remained unconvinced that two merged into one would be better.

Also, in the collection of the Museum of Modern Art, the dozen abstractions of 2005 are now joined by their "photorealist" companion piece. Richter comments about their relationship notwithstanding; it would be a mistake to read their turbulent, grating quality as being in any way descriptive of the destruction of 9/11/01, any more than one should read such markings and strident coloration as romantic *Sturm und Drang* in paintings of a more landscape-like quality. Despite his attraction to Caspar David Friedrich, Richter has consistently eschewed any return to the "pathetic fallacy" wherein human emotion is literally echoed in natural tumult, and there is little ground for thinking that he would use abstraction as a sounding board for similar explicitly manmade thunder and lightening. Moreover, from the scant evidence available about the works in their early stages, they do not appear to have been painted over a realist image, as has been the case on many occasions, and even less likely over a picture of the Twin Towers. Even if such an image is buried in one of the panels of the twelve-part suite, *September* stands as the sole work in which the connection is objectively as well as subjectively inescapable. Instead, it would seem from Richter's statement and the works themselves that a tense, apprehensive, even apocalyptic mood pervades the paintings made at the time of *September*. In that case, they,

like *October 18, 1977*, are a delayed response to a powerful jolt to his system, an aftershock rather than a direct transcription of the initial shock itself, reminding us that Richter is, at his most emotional, a ruminative artist rather than an impetuous "expressionist."

Indeed, there is an element of puzzlement in the way Richter speaks of his having come around to the subject four years after the attack itself, although the drawing for the painting apparently hung in his studio as early as 2004. Still speaking to Obrist, Richter said:

> Probably September 11 bothered me more than I expected. The big drawings also have something to do with that theme; maybe at the time all the pictures did, even if you can't see that now.[5]

To what may we ascribe that slow realization? Moreover, what explains the fact that a theme or awareness so important that it had somehow entered into all his pictures of that period can only be seen in one of them now? The answer, I believe, lies in the very beginning of Richter's mature life as a painter and in his formative years as a person.

Richter's professed ambivalence about the hot-button subjects he has often chosen comes through clearly in his attitude toward *September*. In his exchange with Obrist he said:

> Yes, but I am worried about exhibiting it. On the one hand, it's a perfectly harmless picture, small, and not at all sensational. On the other, it has such a spectacular title, September 11. I should keep it, and if it still looks alright, maybe I'll exhibit it one day later on.[6]

There is certainly a measure of irony in this remark—or, some may argue, coyness—insofar as it is not just the title but the subject itself that is spectacular; although, as previously noted, the attack on the WTC was planned and executed by Al-Qaeda to be a "spectacle" and Richter bears no more responsibility for that dimension of his image than anyone else who has recorded or recycled it in one form or another. Quite the

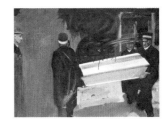

Coffin Bearers
(Sargträger) 1962
135 x 180 cm Oil on canvas

Dead
(Tote) 1963
100 x 150 cm Oil on canvas

Helga Matura with her Fiancé
(Helga Matura mit Verlobtem) 1966
200 x 100 cm Oil on canvas

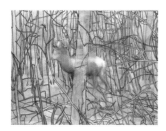

opposite: Richter went out of his way to muffle the most spectacular aspect of the image—the fireball at the center—thereby de-spectacualizing the scene to the degree that that is possible, much as he had done with the grisly police photographs of Meinhof, Baader, and Ensslin in death.

When first confronted by the problems of the "unpaintable" nature of certain images to which he was nevertheless drawn, Richter's strategy was to paint them and then destroy or cancel out the images, or else to give them a trial run as altered photography and then refrain from painting them. The examples of those he treated in this manner are consistently images of war. Perhaps the first is a no-longer extant photomontage maquette for a painting from 1962 called *Firing Squad*. To the repeated upside-down face of a Brigitte-Bardot-like blonde is juxtaposed a documentary picture of men standing with raised hands before a firing squad. Who the men are is impossible to tell from the image, but they seem to be wearing military uniforms, and their execution could be an act of reprisal committed by the Nazis against partisans or soldiers opposing them or by partisans and Allies who were fighting against Nazis. The *Firing Squad* is one of the rare instances in which Richter resorted to the direct juxtaposition of disparate pictures, a method that his close friend Sigmar Polke and his then geographically remote near contemporary Robert Rauschenberg would use extensively for the sake of the unexpected meanings that such dissonance revealed.

Still, for a few years in the early 1960s, the Neo-Dada methodologies of Polke and Rauschenberg held a certain allure for Richter, and the follow-up to *Firing Squad* was an exhibition conceived by Richter but never actually mounted in which the quasi-pornographic pictures of pin-ups he did paint in 1967 were to have been presented in the same space as paintings of naked concentration camp prisoners in their barracks that he included that same year in his omnium-gatherum of images, *Atlas*, but never painted. The idea is simply appalling, and Richter knew it. The dangling question is why did it occur to him, and why did it occur to him at that particular time? Richter has said little on the matter, but context says a lot. These were the years in which the everyday postwar

Stag
(Hirsch) 1963
150 x 200 cm Oil on canvas

Hitler on back of *Stag* (Hirsch)

silence in Germany about Nazi atrocities was finally broken. Between 1963 and 1965, a German Federal Republic Court in Frankfurt held a second, much publicized trial of middle-level SS officers charged with crimes against humanity, the first having taken place in Poland outside of German jurisdiction. The German proceedings followed the Israeli 1960 capture and 1962 trial and execution of the architect of the Final Solution, Adolf Eichmann, although German authorities had had the evidence against the defendants since 1958. Richter's aborted plan to jam one kind of "nudity" against another, one kind of "obscenity" against another, belongs to a critical moment when both historical revelations and cultural shock-tactics cracked the carapace of the New Germany to expose the hidden wreckage and the untouched, still thriving remnants of Hitler's Germany harbored by it.

By 1969, *Atlas* also contained propaganda pictures of Hitler himself that Richter never painted. Previously, Richter had copied onto canvas the likeness of Hitler in an oratorical spasm. Three times, in fact. The first version was shown in 1964 at the Galerie Parnass in Wuppertal in a group exhibition that for the first and last time brought together the core of what later became known as the "Capitalist Realism" contingent, Konrad Lueg (later Konrad Fischer), Sigmar Polke, and Richter. In that painting, *Hitler* (1962), the Führer appears from the chest up passionately gesticulating and haranguing a crowd. The second and third time this stock image was called upon it was used in a playing card-like composite of the same pose—Hitler as "king" or Hitler as "knave"—on the back of *Stag* (1963), and that composite is plainly recognizable under an incomplete coat of white paint. Beginning with the *October* cycle, Richter thereafter abstained from painting overtly sensational images that could readily be connected to the war or to political violence, with the partial exception of *Herr Heyde* (1965), the eponymous portrait of a furtive war criminal arrested in Germany in 1959.

However, from the start of Richter's career in West Germany, images of death and references to the war and its destruction abound, albeit images that focus on everyday mortality and ordinary victims rather

Eight Student Nurses
(Acht Lernschwestern) 1966
95 x 70 cm (each) Oil on canvas

Woman with Umbrella
(Frau mit Schirm) 1964
160 x 95 cm Oil on canvas

than on great catastrophes and notorious villains. Thus, starting with *Coffin Bearers* (1962) and *Dead* (1963), and on through *Helga Matura with her Fiancé* and *Helga Matura*, both from 1966, (Matura, a prostitute, was a sex-murder victim) and *Eight Student Nurses*, also from 1966, (the nurses were killed by Richard Speck in Chicago that same year), Richter's iconography is replete with sinister subjects. The only person he painted at this time and in this context who was famous other than as a victim was Jackie Kennedy in *Woman with Umbrella* (1964); but here again, and in telling contrast to Warhol's many paintings of the grieving Jackie, Richter picked a less than canonical source and never named the subject. What links the equally anonymous dead in *Coffin Bearers* and *Dead*, women who died at the hands of psychopaths, and the widow of an assassinated President? Bizarrely, Speck himself provides something of an explanation. Born December 6, 1941, the day before America's entrance into World War II and the Japanese sneak attack on Pearl Harbor, "a day that shall live in infamy," in Franklin Roosevelt's resonant phrase, and the last time before 9/11/01 that a direct assault on the United States was launched within its territories, Speck told a prison interviewer, "Day I was born all Hell broke loose the next day. Hasn't stopped since."[7]

Bombers
(Bomber) 1963
130 x 180 cm Oil on canvas

It hasn't. And it won't. The bloody trauma that was the twentieth century and is now the twenty-first continues. In Richter's own life, the horrors came closest during the Allied bombing of Germany in which the virtual obliteration of Dresden stands out as one of the most horrifying examples prior to America's "conventional" bombing of Tokyo in 1945 and its use of atomic weapons on Hiroshima and Nagasaki. Dresden was the city where his mother and father met and where he had been born, and it was the ruin to which he returned after the fighting stopped and he was ready to start his independent life. Moreover, Richter recalls hearing the thunder of explosions in and around Dresden during the night of February 13, 1945, from the small town in Saxony where he lived; although, given the distances involved, it is probable that what he heard were radio broadcasts of the raids. The conflagration that resulted burned the core of the city to the ground and incinerated between 24,000 and 40,000 people, the majority of them civilians. In 1951 when Richter returned to his birthplace from the countryside to attend the Dresden Art Academy six years after the attack evidence of the devastation

Mustang Squadron
(Mustang-Staffel) 1964
88 x 165 cm Oil on canvas

lay all around. "Everything had been destroyed" he has said, "There were only piles of rubble to the left and right of what had been the streets. Every day we walked from the academy to the cafeteria through rubble, about two kilometers there and back."[8]

At the time of Dresden's near obliteration, Kurt Vonnegut, who is of German extraction, was a twenty-three-year-old American prisoner of war under guard in "slaughterhouse-five," near the heart of the city. Twenty-five years after the event, and following numerous attempts to recount his experience, Vonnegut presented the story of the destruction of Dresden as a pseudo-memoir interspersed with episodes of science fiction. In its first pages, published in 1969, he recalled:

> Over the years, people I've met have often asked me what I'm working on and I've usually replied that the main thing was a book about Dresden… It wasn't a famous air raid back then, in America. Not many Americans knew how much worse it had been than Hiroshima, for instance. I didn't know that either. I happened to tell a University of Chicago Professor at a cocktail party about the raid, as I had seen it, about the books I would write. He was a member of something called The Committee on Social Thought. And he told me about the concentration camps, and about how the Germans had made soap and candles out of the fat of dead Jews and so on. And all I could say was, "I know, I know, *I know*."[9]

Vonnegut had also seen a city and its citizens all but vanish in a hurricane of flames, leaving behind the surreal predicate to his novel's literary conceit, a barren, lunar landscape all but devoid of moon men. As viewed through the eyes of his fictional alter ego, Billy Pilgrim, "the fire-bombing of Dresden" was, Vonnegut bluntly declared, "the greatest massacre in European history."[10]

Memories of the Allied air campaign and its Dresden paroxysm are the "unpaintable" enormity to which two other groups of pictures made

Jet Fighter
(Düsenjäger) 1963
130 x 200 cm Oil on canvas

XL 513
(XL 513) 1964
110 x 130 cm Oil on canvas

Schärzler
(Schärzler) 1964
100 x 130 cm Oil on canvas

by Richter unmistakably point. The first are paintings of military aircraft in flight, beginning with *Bombers* (1963), in which high-altitude planes with American insignia unload ribbons of steel-encased explosives on an invisible target. Other pictures in the group include *Stukas* (1964), showing German dive bombers in action and *Mustang Squadron* (also 1964), portraying American fighters buzzing the landscape beneath. Referring to the same historical period, *Airplanes* (1964) would appear to be a view from the ground up at anti-aircraft fire directed toward bombers flying overhead, whereas *Jet Fighter* (1963), *Phantom Interceptors*, *Schärzler*, and *XL 513* (all 1964) feature supersonic jets of the Cold War era.

Phantom Interceptors
(Phantom Abfangjäger) 1964
140 x 190 cm Oil on canvas

The second series consists of aerial views of major cities—views someone in the cockpit or bomb bay of a warplane might have. Not that one would know from the image that the urban terrain actually faced such a threat, and not that wounds have actually been opened in that terrain's flesh. Indeed, a number of these *Cityscapes* resemble the sorts of promotional pictures that developers commission to lure clients to their version of a modern, clean, prosperous and—above all—affordable utopia. By that token, some of the most stream-lined of these pictures may be understood as trick mirrors reflecting and reflecting on Germany as it was rebuilt on the rubble of World War II. But other works of this kind suggest the opposite outcome: the fall or pulverization of cities. One of the largest and earliest of the *Cityscape* series, *Cathedral Square, Milan* (1968),

Mustang Squadron
(Mustang-Staffel) 2005
88 x 150 cm Laserchrome paper
behind reflective glass (Diasec)
Richter's studio, Cologne

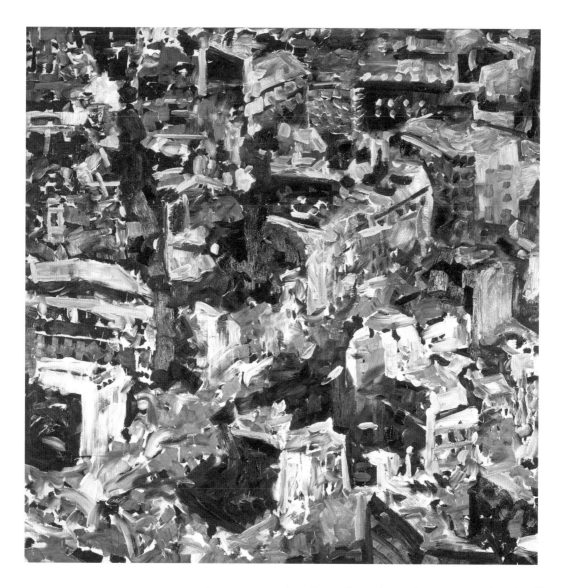

is not an overview but rather a long vista encompassing the filigreed late-Gothic church and the nineteenth-century commercial arcade; and it is painted in a striated manner that causes both these "temples"—one dedicated to religion the other to commerce—to visibly shiver or shake. The first full aerial views begin the same year and range in the degrees of

Cityscape Paris
(Stadtbild Paris) 1968
200 x 200 cm Oil on canvas

resolution and stability of the image from *Cityscape Madrid* (1968), which is bathed in a crisp volume-defining chiaroscuro light, to *Cityscape Paris* (1968), in which the buildings seem to be on the verge of crumbling.

That apparent fragility reverberates throughout the picture. And, still more unnervingly in the mind when one recalls the fate Hitler decreed for Paris—or, what Walter Benjamin, its quintessential and ultimately tragic *flaneur*, had called the "capital of the nineteenth century"—should the city near surrender to the Free French and the Allies: namely total annihilation. Only the refusal of the military Governor of Paris, General Dietrich von Choltitz, to obey the order to level the city with explosives saved it. Then there are paintings like *Cityscape PL* (1970) in the collection of the Museum of Modern Art in New York, in which the viewer suspects that some kind of fury has already been spent on the generally inchoate, unidentifiable town at ninety degrees to the eye. Lastly, after a pause of thirty years comes an oblique confirmation of Richter's preoccupation with memories of aerial bombardment in the digitally reconfigured appropriation of an Allied combat surveillance photo, *Bridge, February 14, 1945* (2000) which happened to be the last day of the air assault on Dresden, though this particular image shows a bombed out stretch of the Rhine river as it passes through Cologne, where the artist now lives.

Characteristically, Richter is vague or evasive when asked point blank about the significance of such specific and presumably meaningful details in his work. As essayist W. G. Sebald has noted in his reflections on post-war reticence about Allied bombing, *On the Natural History of Destruction*, such reactions are characteristic of a more general inhibition regarding the experience that originates in German society's overall inability to come to terms with its war-time past. Virtually alone among artists of his generation Richter effectively broke that taboo in pictures, but he has nevertheless hesitated to do so in words. When pressed in a 2001 interview with this author about the fact that many of his early pictures reference World War II, Richter fended off questions about the import of particular images and protested that he was being "put on the couch."

Cityscape PL
(Stadtbild PL) 1970
200 x 200 cm Oil on canvas

Cathedral Square, Milan
(Domplatz, Mailand) 1968
275 x 290 cm Oil on canvas

View of the bombed city of Dresden
1945

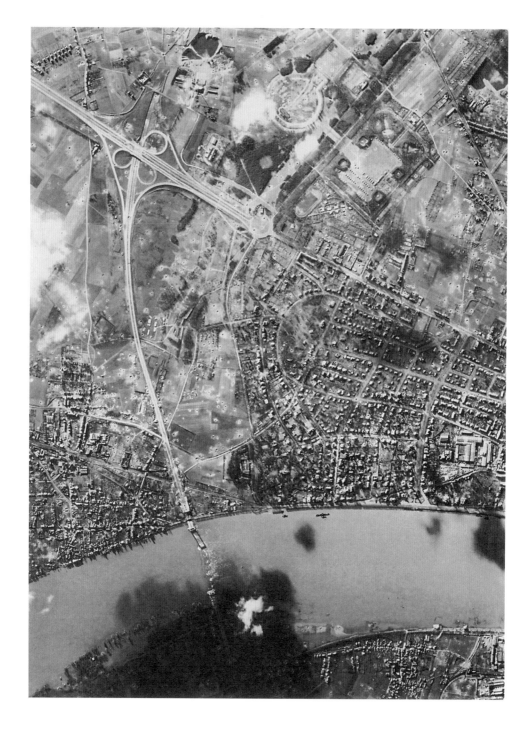

Bridge 14 FEB 45 (III) 2000
100 x 70 cm Offset print on lightweight cardboard

But as any canny "patient" instinctively knows, well-phrased disclaimers may be the best way to lead the "analyst" past all but unavowed taboos to unutterable truths. And so, when asked why, during the 1960s, he painted American warplanes flying over Germany, Richter replied, "But this painting—the American bomb[er]—was forbidden. You were not allowed to take it seriously. You could only take it as a joke." When I replied, "You didn't paint it as a joke," Richter's rejoinder was cagey but revealing.

> No, but I was satisfied that it was taken as such. I would have been embarrassed if it were too serious. It was not an accusation; I was never accusing the American. I never wanted to accuse anything, except maybe life and how shitty it is. But never … after all, they were right. Everything was fine (laughter).[11]

For Richter, the dilemma of painting the war would seem to have hinged on wanting to register the enormity of the trauma he and his generation experienced without "taking sides" in a situation where he could not in good conscience do so. As a nation, Hitler's Germany had brought about its own destruction, but as someone who at a distance felt the impact of the overwhelming counterforce unleashed upon his country, Richter could not stand apart from its fate, either. To make "Pop" pictures of B-29s unloading their deadly cargo was thus to "make a joke" of something that was tragic because the context of the period made it impossible to see tragedy in what seemed like just punishment in the eyes of those who had suffered the Nazi onslaught, even as it seemed like arbitrary retribution to the civilians on whom the bombs rained down. Richter was a less-than-innocent, less-than-guilty target among many other targets in a war quite literally carried on over their heads. In a contest between armies who routinely sacrifice noncombatants, the only honest option for someone less than innocent of, but less than guilty for the excesses of his or her homeland is to be a candid witness of what happens when, as Richter avers, life is "shitty" and violent death becomes the ineluctable centerpiece and mystery of existence.

However, for reasons that should by now be self-evident, bearing witness does not imply special access to the essential meaning of critical events. Nor does being in a position to see those events with one's own eyes privilege the testimony of any individual, no matter where they stand in relation to the presumed center of the drama, since so many other eyes are trained on it from so many other uniquely revelatory positions. Logically, this observation is elementary, but as soon as discussion moves from the abstract to the concrete, agreement vanishes in the so-called "fog of war," that atmosphere of crisis and ambiguity in which opposites confront each other only to lose their bearings, that moment of truth in which sharply defined antagonists begin to resemble each other in their confusion and desperation and truth vaporizes and indiscriminate death has the final word.

To say this is not to descend into moral relativism, despite what those who never doubt their own righteousness may claim. Richter's unwillingness to accuse or excuse, his strict abstinence from special pleading, and his refusal to create false equivalencies between what Germans did to others and what Allied bombers did to Germans is in fact a staunch moral position, one equivalent to Goya's harrowingly impartial declaration in the *Disasters of War*, "I saw this." But as Goya's great indictment of the systematic terror perpetrated on the "benighted" Spaniards by the "enlightened" troops of Napoleon's revolutionary army makes manifest, no one can penetrate the darkness in which organized murder takes place on all sides. At best, we see just a shadow of the worst.

Such ideological aberrations and the unforgivable cruelties they engender are a constant—arguably, *the* constant—of modernity, with bombing being zealotry's most advanced and reliable technology (in the language of traditional anarchism, its "infernal engine" or, in that of the nuclear era, its "ultimate weapon.") Accordingly, Terror is the name of every excess committed for the sake of an abstraction as well as that of the barbarism prompted by intimate hatreds and allegiances, whether those acts are perpetrated by a State or by insurgents, by imperial armies or suicidal individuals, by bureaucrats or truck drivers, by the haves or the have-nots.

In a more complete citation of Richter's previously quoted words on painting the *October* cycle, one hears an intellectual refrain that seemingly anticipates the artist's return to one of the themes that inform *September*:

> That is the most impressive thing, to me, and the most inexplicable thing; that we produce ideas which are almost always not only utterly wrong and nonsensical but also dangerous. Wars of religion and the rest; it's fundamentally all about nothing, about pure blather—and we take it utterly seriously, fanatically, even unto death.[12]

In the course of the agonizingly long conflicts within and among nations in the post-war, post-colonial era, the center of ideological gravity has shifted dramatically from "revolutionary struggle" to "wars of religion," from a Cold War between entities ostensibly representing Democracy and Communism, to the furious conflagrations sparked by what has been called a "clash of civilizations" in some quarters and a "new Crusade" in others. To that extent, *September* is a coda to the *October* cycle, the image of self-immolation in pursuit of self-determination, of a totalizing doctrine consummated by death.

But unlike the *October* cycle, in which Richter eschewed painting any pictures of the RAF's victims, the haze of *September* subsumes those who suffered in the attack along with those who perpetrated it. Furthermore, through abysmal dilation, it encompasses all who saw the attack without having endured its worst effects. Finally, it envelops anyone who approaches it whether or not they were awake that morning to watch what happened from any vantage point, near or far. A focal point of thought that troubles the eye because of its small scale, indeterminate depth of field, and lack of vanishing point, while troubling the mind by condensing every uncertainty, contradiction, and ambivalence the viewer brings to it, *September* commemorates the events of 9/11/01 as well as everything that led up to them and everything that has ensued since and might be called a consequence, by holding all in perpetual suspension and irresolvable tension.

To think about that day you have only to look and by looking immerse yourself in and become a part of that mantle of anxious ambiguity. By doing this, you will share it with those who still wonder what happened and why, those who cannot stop asking themselves what has been irrevocably changed or lost and what may yet be salvaged from the carnage and the confusion. As a New Yorker who was "there," "then," and has yet to grow accustomed to the depth and permanence of the trauma, my most urgent questions concern the degree to which my fellow countrymen have awakened from the illusion that "it can't happen here," and, correspondingly, the measure to which they have overcome the panic that drove them to abandon common sense and common decency, while scorning their most cherished principle in the vain effort to recreate an always irrational sense of invulnerability.

I don't know what Richter's foremost preoccupations in painting this work were, or what they are now that it has found a home in the place where the Twin Towers once stood. I do know more fully than ever before that our histories as people of different generations and different, formerly antagonistic countries, as well as our fates as citizens of a ruthlessly fractured and manipulated world, are inextricably entwined, and that the many meanings this picture has are knotted into that mesh.

Robert Storr—September 2009

1
In a conversation between Richter and Jan Thorn-Prikker about the *October* cycle, there was an extended exchange regarding what was not "paintable."

Thorn-Prikker Were you confident from the very start that the terrorism theme was paintable?

Richter The wish was there that it might be—had to be—paintable. But there have been some themes that weren't. In my mid-twenties, I saw some concentration camp photographs that disturbed me very much. In my mid-thirties I collected and took photographs and tried to paint them. I had to give up. That was when I put photographs together in that weird and seemingly cynical way in the *Atlas*.

Thorn-Prikker Did you never have the feeling that such picture material might be taboo?

Richter No, never. If only because I have always regarded photographs as pictures. But the risk I was running was perfectly clear. There are plenty of bad examples of people hitching themselves to some big, attractive theme and ending up with mere inanity.

Gerhard Richter—Writings 1961–2007, pp. 226-7.

2
Ibid., "Notes 1983," p. 103.

3
Another work made by Richter in response to the conflict in the Middle East was an "artist's book" entitled *War Cut* in which highly tactile photographic details of his abstract pictures are jarringly juxtaposed to excerpts from newspaper reports on the Iraq war from the *Frankfurter Allgemeine Zeitung*. The trade edition of the book was originally published in 2004 by Verlag der Buchhandlung Walther König, Cologne and the Musée d'Art Moderne de la Ville de Paris.

4
Ibid., *Gerhard Richter—Writings 1961–2007*, "Interview with Hans Ulrich Obrist," p. 527.

5
Ibid., p. 526.

6
Ibid., p. 527.

7
Richard Speck, as taped in prison in 1989. Transcribed from an A & E (Arts & Entertainment Network)/Biography broadcast, 1996, narrated by Bill Kurtis.

8
Richter as quoted in *Gerhard Richter: A Life in Painting* by Dietmar Elger, University of Chicago Press, 2009, p. 11.

9
Kurt Vonnegut, Jr. *Slaughterhouse Five*, Dell Publishing Company, New York, 1969, p. 10.

At the February 2002 opening of *Gerhard Richter: Forty Years of Painting,* Richter was approached at the end of the press conference by a grizzled man with a walrus moustache who warmly shook his hand and said something to the effect, "I was there too." The man was Kurt Vonnegut, but Richter did not recognize him, and the intended meeting of two eyewitness artists was over before it began. Richter, misunderstanding the name Vonnegut gave, mistook him for Kirk Varnedoe, then MoMA's Chief Curator of Painting and Sculpture, and expressed his puzzlement because he thought, correctly, that Varnedoe was too young to have been present during the Dresden bombardment. In any case, Richter himself was not present.

10
Ibid., p. 101. Vonnegut's seemingly hyperbolic assertion that the fire bombing of Dresden was the "greatest massacre in European history" was in line with some post-war estimates that went as high as 500,000 casualties, and of course must be considered in light of the word massacre's usual meaning; that is a single, concerted military slaughter. Needless to say the cumulative killings by German soldiers on the Eastern Front during the course of the war exceed that total. Meanwhile, more recent studies set the likely death toll in Dresden under 50,000 and one investigation commissioned by the city produced figures as low as 25,000, though that is still a staggering number of lives lost. For comparison, the atom bombs dropped on Japan in August of 1945 killed approximately 140,000 in Hiroshima and 80,000 people in Nagasaki. The Allied Forces' fire-bombing of Tokyo carried out the previous March used only non-nuclear weapons, and resulted in between 88,000 and 97,000 deaths. At the beginning of the war in 1940 the Luftwaffe launched a surprise attack on the English city of Coventry, using incendiary bombs along with other heavy munitions that levelled much of the city. Out of a population of 330,000 roughly between 600 and 1000 people were killed in the raids. In the final analysis it would seem that Dresden's horror lies somewhere between that of Coventry and Nagasaki.

11
Gerhard Richter—Writings 1961–2007, "Interview with Robert Storr," p. 400.

12
Ibid., "Conversation with Jan Thorn-Prikker," p. 231.

September : The Painting

September
(September) 2005
52 x 72 cm Oil on canvas
The Museum of Modern Art, New York
(gift of Joe Hage and Gerhard Richter)

Followed by 5 details shown actual size

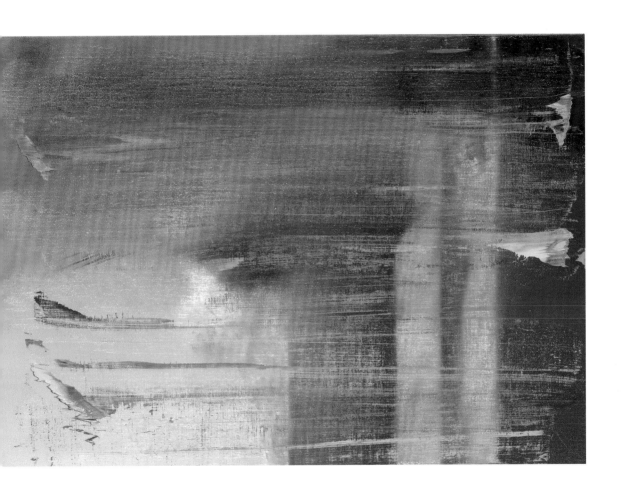

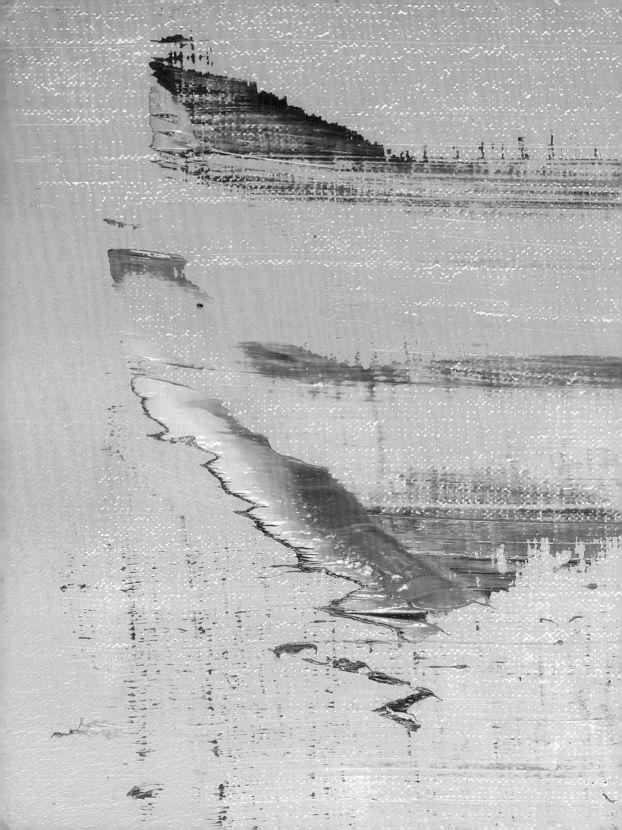

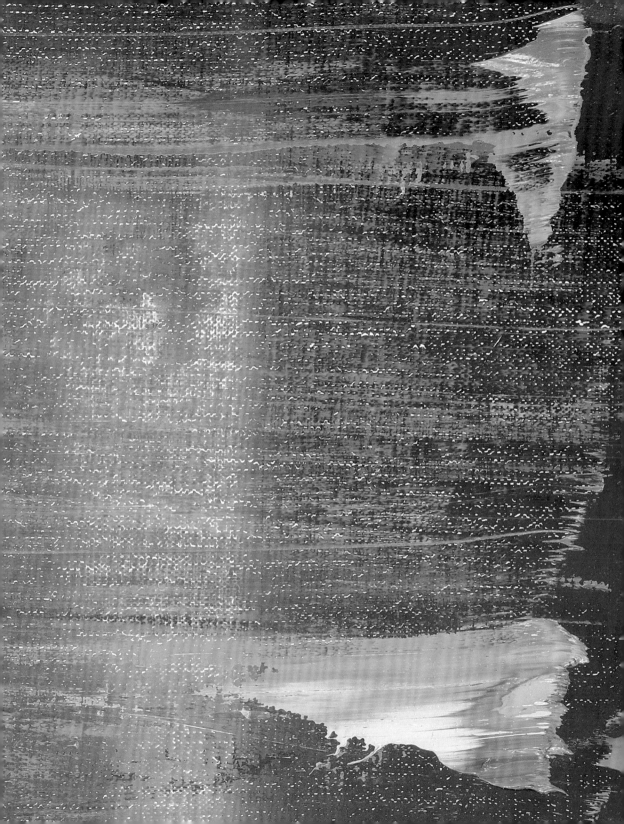

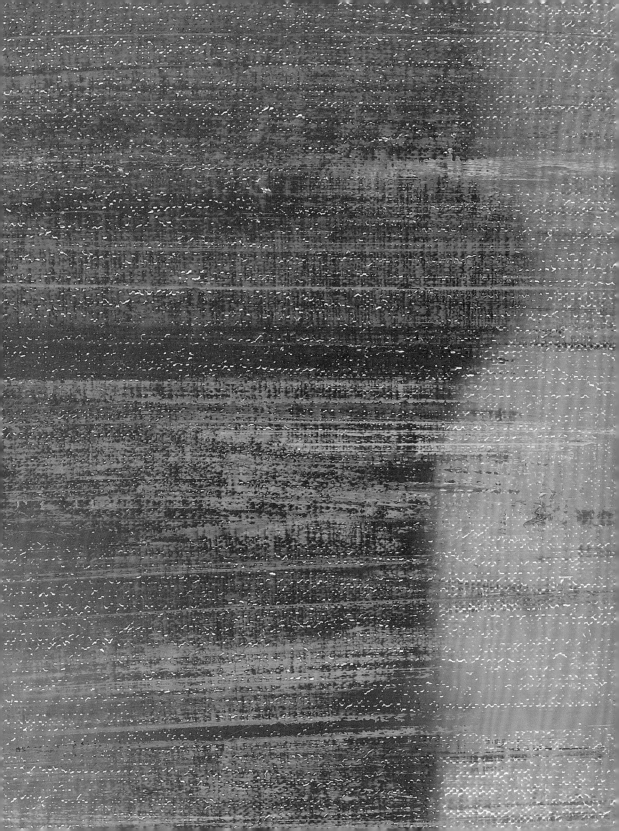

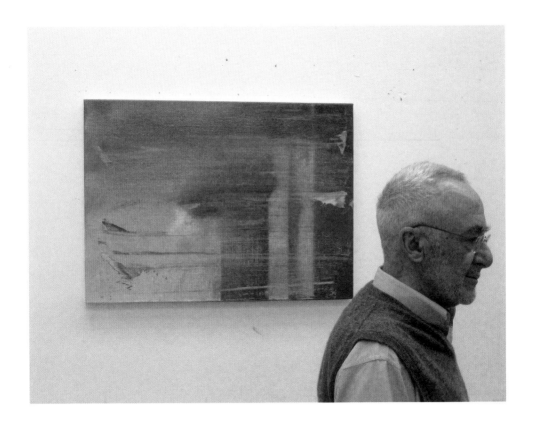

List of Illustrated Works

Detail of *Atlas*, Sheet 744
2006
p. 22

Drawing I (Zeichnung I)
2005
151 x 102 cm
Graphite on paper
p. 30 (top)

Drawing II (Zeichnung II)
2005
151 x 102 cm
Graphite on paper
p. 30 (bottom)

Drawing III (Zeichnung III)
2005
151 x 102 cm
Graphite on paper
p. 31 (top)

Drawing IV (Zeichnung IV)
2005
151 x 102 cm
Graphite on paper
p. 31 (bottom)

Preparatory drawing for *September*
2005
52 x 72 cm
p. 32

October 18, 1977 (18. Oktober 1977)
1988
Cycle of 15 paintings:

Youth Portrait (Jugendbildnis)
1988
67 x 62 cm
Oil on canvas
Catalogue Raisonné: 672-1
The Museum of Modern Art, New York, USA
p. 34

Dead (Tote)
1988
62 x 67 cm
Oil on canvas
Catalogue Raisonné: 667-1
The Museum of Modern Art, New York, USA
p. 35 (top)

Dead (Tote)
1988
62 x 62 cm
Oil on canvas
Catalogue Raisonné: 667-2
The Museum of Modern Art, New York, USA
p. 35 (middle)

Dead (Tote)
1988
35 x 40 cm
Oil on canvas
Catalogue Raisonné: 667-3
The Museum of Modern Art, New York, USA
p. 35 (bottom)

Cell (Zelle)
1988
200 x 140 cm
Oil on canvas
Catalogue Raisonné: 670
The Museum of Modern Art, New York, USA
p. 36 (top)

Hanged (Erhängte)
1988
200 x 140 cm
Oil on canvas
Catalogue Raisonné: 668
The Museum of Modern Art, New York, USA
p. 36 (bottom)

Funeral (Beerdigung)
1988
200 x 320 cm
Oil on canvas
Catalogue Raisonné: 673
The Museum of Modern Art, New York, USA
p. 37 (top)

Record Player (Plattenspieler)
1988
62 x 83 cm
Oil on canvas
Catalogue Raisonné: 672-2
The Museum of Modern Art, New York, USA
p. 37 (2nd from top)

Arrest 1 (Festnahme 1)
1988
92 x 126 cm
Oil on canvas
Catalogue Raisonné: 674-1
The Museum of Modern Art, New York, USA
p. 37 (2nd from bottom)

Arrest 2 (Festnahme 2)
1988
92 x 126 cm
Oil on canvas
Catalogue Raisonné: 674-2
The Museum of Modern Art, New York, USA
p. 37 (bottom)

Confrontation 1 (Gegenüberstellung 1)
1988
112 x 102 cm
Oil on canvas
Catalogue Raisonné: 671-1
The Museum of Modern Art, New York, USA
p. 38 (top)

Confrontation 2 (Gegenüberstellung 2)
1988
112 x 102 cm
Oil on canvas
Catalogue Raisonné: 671-2
The Museum of Modern Art, New York, USA
p. 38 (middle)

Confrontation 3 (Gegenüberstellung 3)
1988
112 x 102 cm
Oil on canvas
Catalogue Raisonné: 671-3
The Museum of Modern Art, New York, USA
p. 38 (bottom)

Man Shot Down 1 (Erschossener 1)
1988
100 x 140 cm
Oil on canvas
Catalogue Raisonné: 669-1
The Museum of Modern Art, New York, USA
p. 39 (top)

Man Shot Down 2 (Erschossener 2)
1988
100 x 140 cm
Oil on canvas
Catalogue Raisonné: 669-2
The Museum of Modern Art, New York, USA
p. 39 (bottom)
[End of *October* cycle]

Inpainting (Gray)
(Vermalung (grau))
1972
250 x 250 cm
Oil on canvas
Catalogue Raisonné: 326-3
Hessisches Landesmuseum, Darmstadt, Germany
p. 48

January (Januar)
1989
320 x 400 cm
Oil on canvas
Catalogue Raisonné: 699
Saint Louis Art Museum, Saint Louis, USA
p. 53

December (Dezember)
1989
320 x 400 cm
Oil on canvas
Catalogue Raisonné: 700
Saint Louis Art Museum, Saint Louis, USA
p. 54

November (November)
1989
320 x 400 cm
Oil on canvas
Catalogue Raisonné: 701
Saint Louis Art Museum, Saint Louis, USA
p. 55

Firing Squad (Erschießung)
1962
170 x 200 cm
Oil on canvas
p. 56 (top)

Mr. Heyde (Herr Heyde)
1965
55 x 65 cm
Oil on canvas
Catalogue Raisonné: 100
p. 56 (bottom)

Coffin Bearers (Sargträger)
1962
135 x 180 cm
Oil on canvas
Catalogue Raisonné: 5
Pinakothek der Moderne, Munich, Germany
p. 57 (top)

Dead (Tote)
1963
100 x 150 cm
Oil on canvas
Catalogue Raisonné: 9
p. 57 (middle)

Helga Matura with her Fiancé (Helga Matura mit Verlobtem)
1966
200 x 100 cm
Oil on canvas
Catalogue Raisonné: 125
Museum Kunst Palast, Düsseldorf, Germany
p. 57 (bottom)

Stag (Hirsch)
1963
150 x 200 cm
Oil on canvas
Catalogue Raisonné: 7
p. 58

Hitler on back of *Stag* (Hirsch)
1963
200 x 150 cm
Oil on canvas
p. 59

Eight Student Nurses (Acht Lernschwestern)
1966
95 x 70 cm (each)
Oil on canvas
Catalogue Raisonné: 130
Private collection, Zurich, Switzerland
p. 60 (top)

Woman with Umbrella (Frau mit Schirm)
1964
160 x 95 cm
Oil on canvas
Catalogue Raisonné: 29
Daros Collection, Zurich, Switzerland
p. 60 (bottom)

Bombers (Bomber)
1963
130 x 180 cm
Oil on canvas
Catalogue Raisonné: 13
Städtische Galerie, Wolfsburg, Germany
p. 61

Mustang Squadron (Mustang-Staffel)
1964
88 x 165 cm
Oil on canvas
Catalogue Raisonné: 19
p. 62

Jet Fighter (Düsenjäger)
1963
130 x 200 cm
Oil on canvas
Catalogue Raisonné: 13-a
p. 63 (top)

XL 513 (XL 513)
1964
110 x 130 cm
Oil on canvas
Catalogue Raisonné: 20-1
Museum Frieder Burda, Baden-Baden, Germany
p. 63 (middle)

Schärzler (Schärzler)
1964
100 x 130 cm
Oil on canvas
Catalogue Raisonné: 17
p. 63 (bottom)

Phantom Interceptors (Phantom Abfangjäger)
1964
140 x 190 cm
Oil on canvas
Catalogue Raisonné: 50
Froehlich Collection, Stuttgart, Germany
p. 64

Mustang Squadron (Mustang-Staffel)
2005
88 x 150 cm
Laserchrome paper behind reflective glass (Diasec)
Editions Catalogue Raisonné: 131
p. 65

Cityscape Paris (Stadtbild Paris)
1968
200 x 200 cm
Oil on canvas
Catalogue Raisonné: 175
Froehlich Collection, Stuttgart, Germany
p. 66

Cityscape PL (Stadtbild PL)
1970
200 x 200 cm
Oil on canvas
Catalogue Raisonné: 249
The Museum of Modern Art, New York, USA
p. 67 (top)

Cathedral Square, Milan (Domplatz, Mailand)
1968
275 x 290 cm
Oil on canvas
Catalogue Raisonné: 169
p. 67 (middle)

Bridge 14 FEB 45 (III)
2000
100 x 70 cm
Offset print on lightweight cardboard
Editions Catalogue Raisonné: 115
p. 68

September (September)
2005
52 x 72 cm
Oil on canvas
Catalogue Raisonné: 891-5
The Museum of Modern Art, New York, USA
(gift of Joe Hage and Gerhard Richter)
p. 77

Photo Credits

Thanks to Konstanze Ell from Gerhard Richter's studio and to
Carina Krause and Bruce Cameron from Gerhard Richter's website,
www.gerhard-richter.com

First published 2010 by order of the Tate Trustees
by Tate Publishing, a division of Tate Enterprises Ltd,
Millbank, London SW1P 4RG
www.tate.org.uk/publishing

A catalogue record for this book is available from the British Library

ISBN 978 1 85437 964 1

Distributed in the United States and Canada by Harry N. Abrams, Inc., New York

Library of Congress Control Number: 2010924847

Designed by Herman Lelie and Stefania Bonelli
Assisted by Thomas George Ramasami
Edited by Bruce Benderson
Proofreading by Matt Price
Research by Carina Krause
Produced by fandg.co.uk
Printed in Italy by EBS, Verona

Cover image: *September*, (CR 891-5), 2005, 52 x 72 cm, oil on canvas